COLOR PIPELINE

G5

"I believe that the electronic image will be the next major advance.

Such systems will have their own inherent and inescapable structural characteristics, and the artist and functional practitioner will again strive to comprehend and control them."

—Ansel Adams, 1981

COLOR PIPELINE

Revolutionary Paths to Controlling Digital Color

Ted Dillard

LARK BOOKS

A Division of Sterling Publishing Co., Inc.

New York / London

Editor: Kara Helmkamp
Book Design: Ginger Graziano
Cover Design: Thom Gaines
Editorial Assistance: Frank Gallaugher
Illustrations: Susan McBride

Library of Congress Cataloging-in-Publication Data

Dillard, Ted, 1956-
 Color pipeline : revolutionary paths to controlling digital color / Ted Dillard. -- 1st ed.
 p. cm.
 Includes index.
 ISBN 978-1-60059-392-5 (pb with flaps : alk. paper)
 1. Color photography--Digital techniques. I. Title.
 TR267.D55 2009
 778.6--dc22
 2008019093

10 9 8 7 6 5 4 3 2 1

First Edition

Published by Lark Books, A Division of Sterling Publishing Co., Inc.
387 Park Avenue South, New York, N.Y. 10016

Distributed in Canada by Sterling Publishing,
c/o Canadian Manda Group, 165 Dufferin Street
Toronto, Ontario, Canada M6K 3H6

Distributed in the United Kingdom by GMC Distribution Services, Castle Place, 166 High Street, Lewes, East Sussex, England BN7 1XU

Distributed in Australia by Capricorn Link (Australia) Pty Ltd., P.O. Box 704, Windsor, NSW 2756 Australia

If you have questions or comments about this book, please contact:
Lark Books
67 Broadway, Asheville, NC 28801
(828) 253-0467

Manufactured in China

ISBN 13: 978-1-60059-392-5

For information about custom editions, special sales, premium and corporate purchases,
please contact Sterling Special Sales Department at 800-805-5489 or specialsales@sterlingpub.com.

TABLE OF CONTENTS

Part 4: Under the Hood: Controlling Color

Part 5: The Open Road: Color Workflow in the Real World

Part 6: Shortcuts, Detours, and the Scenic Route: The Color Managed Workflow211

DIGITAL COLOR PIPELINE

Life After Color Management

A round 2000-2004, the sure bet to filling a room with photographers was to give a talk about color management. In my opinion, color management was only beginning to work at that point. Before that—before Photoshop 6—there was not even a decent framework to work with. Shortly after Photoshop 6 hit, we saw various color management "solutions,"—better displays and printers, more understanding of the systems—but the system still had some lingering problems. After that, we saw a maturing of color management: a refining of the tools, a better understanding of the system, and a

introduction

more precise way of talking about how to use it. As the system evolved and started working, interest in color management was eclipsed by more pressing issues of the day, such as workflow (to deal with mountains of image data created alongside digital photography).

I call this "Life After Color Management" because now is the time to step back and take a look at the working system as a whole; many concepts, terms, and practices are now obsolete, and pieces of the puzzle were simply left out of explanations for fear of adding confusion to an already muddy concept. It is time to reanalyze digital color management and attempt to push our understanding of the process to a more practical and applicable level.

Part of my job is to act as a translator between engineers and artists, although the lines

between the two disciplines sometimes blur and even completely cross over. I strive to be very clear and precise about terms and their use (my background in Philosophy, I guess), but I know that in the strictest language of colorimetry, I'm going to drive some folks crazy, not the least of whom is my friend Joe Holmes, who has been a great help to me in decoding this science so I could wrap my head around it. All I can say is, bear with me. There's a method to my madness, and, as Prof. Steve Weber once told me (after my rant about a translation of Heidegger), words are all we have to work with. I'm going to toss some venerable old terms aside—sweep the floor, as it were—and start with a fresh set of definitions and ideas to help translate this elegantly simple system to manage colors into something we can all understand and appreciate.

PART 1:
LEARNING THE ROPES:
COLOR BASICS

I n order to create a color managed work-
flow, it is important to understand the
physics of color, how we interpret color,
and how we translate seeing color into a
controllable digital medium.

A Glossary of Misused Digital Imaging and Color Management Terms

Clear communication depends entirely on a commonly accepted understanding of terms. It seems to me that when two informed, intelligent people can't reach a rational, reasonable understanding about a point, the root issue is that one concept or definition in the discussion

is being seen two different ways.

Think of the famous parable of the two blind men and the elephant. It's the classic preface to any discussion concerning differences of opinions among informed people. The punch line is that each blind man has what he thinks is the perfect definition of an elephant, and they are both right, to a certain extent—one is touching the elephant's leg and the other the elephant's trunk. An elephant leg does seem like a tree; the trunk does seem like a serpent. They could argue to the death about their view of the elephant, and they would both be completely right—and, of course, just as wrong.

I offer the following terms because they are vague, imprecise, wrong in their typical usage, or are saying a very simple thing in a complicated way. Let's start with my favorite—the word I love to hate.

Algorithm

First of all, I have yet to see or hear this word used where someone can tell me what truly it means. Second, it can almost always be replaced by the word "computation," or "processing," or something similar, belying its imprecise definition. Third, I almost always hear it used at cocktail parties and online forums (which are the same as cocktail parties but without the fancy drinks) by people trying to impress me with how much they know about everything.

The truth is, they are probably using it correctly. An algorithm is a series of mathematical instructions—an if/then list—that is the basis for any computer program, from the most basic of programs ("Basic"— old computer language that even I can write in) to the most sophisticated applications. Algorithms are the basic recipes that make anything work. Why not use a term that is a little more specific and actually means something?

dpi

This term is widely misused. Designers say they need files with a resolution of 300dpi. People printing on ink jet printers swear that you need to send images to the printer as some factor of 720 or 1440 or something, like, say, 360dpi because it works with the math of a printer that prints at 1440 and 2880dpi. Even some industry professionals say that a magazine is printed at 165dpi. I say, "Ha!"

The fact is, dpi (dots per inch) is simply not interchangeable with ppi (pixels per inch) and has no relationship whatsoever to the "dpi" listed on the box of your Epson printer. I would argue that no one uses "dots per inch." (See page 30 for a full explanation of dpi and ppi.)

Graphic designers are actually thinking of ppi, not dpi, and printers aren't actually using dots—they're more like "droplets," and are measured by volume (picolitres). The screening and dithering of the printer doesn't give a hoot

Apple's Aperture and the oft misused "DPI."

about the pixels per inch you're feeding it. The one industry that does use dots per inch is the offset printing industry, but they actually call it "lines-per-inch" because a 165-line screen is how you make a 165 "dpi" halftone screen.

The thing that drives me nuts about this is the fact that some imaging programs, notably Apple's Aperture (and embarrassingly to all those who've invested in the Apple system), uses "dpi" when they mean "ppi."

For shame! Other applications do it too, but most are not dubbed as "professional" imaging tools.

Interpolate

Here is a venerable term from mathematics that was used to lie to us about the capabilities and presumed quality of images produced by certain scanners. There was "resolution" (interpolated) and in small type at the bottom of the spec-sheet, "hardware resolution." Interpolate means,

mathematically, to calculate a value within a series, based on the series. Many people seem to think that interpolate means "making up data," but in fact, it means projecting data within a trend, based on the pattern of that trend. Its kissin' cousin is "extrapolate," which means to project data outside of a range, based on the logistics of that range. (The Red Sox will win the Series this year, if they keep playing the way they have been so far. Yes, I'm from Boston.)

The point is, not only is interpolation a good thing, but it's a very necessary thing. Resizing up or down uses calculations that interpolate, and that's called "resampling." Individual red, green, and blue pixels are "interpolated" to create RGB pixels, and that is called "demosaicing." I'd also argue that the process of digitizing an analog signal is based on interpolation. If someone tells you that a scanner, with an interpolated resolution of 4800ppi, is just as good as a scanner with a hardware resolution of 4800ppi, then they're a lying liar. If they tell you that their method of interpolation is a good resampling method—better than Photoshop—I may be skeptical, but at least they're speaking correctly.

Metamerism

Here's an unfortunate one: metamerism is a very specific and important phenomenon in color science, and because of one printer—the Epson P2000—metamerism was introduced to

many photographers as an evil thing that the printer did. The prints from the P2000 would radically change color depending on the color of the viewing light. You could view a print under daylight and it would seem fine, but if you viewed it under gallery lights it would suddenly look dramatically red, and under fluorescents it would look green. Metamerism was to blame, but not for the right reasons.

Technically, metamerism is the phenomenon in which two different things (i.e. prints) with different spectral properties (different colors) illicit the same sensory response (look like the same color). You can look at two patches of ink meant to reflect different colors but look the same to your eyes under a certain color of light. Metamerism enables you to print a green-looking color with droplets of non-green ink—specifically, cyan and yellow.

It is an interesting and important term to know and understand, but in a room full of photographers who have ever owned or heard of the Epson P2000, it has too much baggage.

WYSIWYG

OK, just stop right there. WYSIWYG stands for "what you see is what you get." It implies that you can set up a color management system so whatever the monitor shows will come out of the printer. There are several problems with this stance. First, it sets up impossible expectations. Second, dependence on a system like this is counter-productive for any photographer who wants to "visualize" the final version of their work, and third, well, it just sounds dumb.

In my humble opinion, this is the problem: displays (such as a computer monitor) make color with light, while printers make color with ink. You will never make the printer look "like" the display. Implying that this is possible sends people down the wrong path. The path they should be going down—the path to predictable color—is not WYSIWYG, but consistency and discipline. Show me a decent display and a printer that always prints the same response to that display, and I'll show you a system I can work with.

Good color management is about creating a system that is predicable through consistency, not by trying to make it WYSIWYG. A photographer learns to visualize, not by leaning on some WYSIWYG crutch, but by working with consistency. By using a system that always does the same thing, you learn the response, it becomes reflexive, and you learn to visualize the result.

Let's get right to it. What exactly is color?

Color is a perception; it is something we see with our eyes. Colors—pigments, dyes, tones, and values—certainly exist beyond our senses, but in and of itself color is perceived.

Color is an experience.

To underscore this point, let's use the example of the CIE (International Commission on Illumination; the acronym is derived from the French name) and their description of color. Back in the 1930s, the CIE developed a mathematical way to describe color based on the incremental steps of color that people could see. The subjects viewed and evaluated color samples until the researchers determined what

they felt were the smallest steps of color variation that humans could see. Then they created a numeric value for these steps and, by basing those values on three dimensions of color, created CIE XYZ and CIE LAB—the two standards of colorimetry and color management that we still use today.

I'm not going to talk about wavelength and black-body radiation here, or go into too much detail on things like metamerism, because—although that is how color is communicated to our eyes and how light and colors work—it is not about color. It does not address our perception of color.

I am, however, going to talk about the two ways that colors are made, because it has a direct impact on our exploration of the experience of color.

Additive and Subtractive Color

The two basic ways that color is made are with light and with materials. (Let's keep it simple here: "materials" means dyes and pigments, or even more simply, paint.) The first type of color is called "additive" color, and is created by light. With either method, you have color "primaries" that you can combine in various increments to create any color. The primaries of additive color are red, green, and blue.

Perhaps you have seen this illustration before; it demonstrates the additive properties of the

color of light. The three primary colors combine in the center to make white, and where they overlap you get a mixture of the two colors (see the image on the opposing page). In additive color, the absence of light makes black. The reverse of this is the prism: you start with white light and the prism splits up the components

of the light into its separate colors. Why is this important? Well, this is how your display (your computer's monitor) makes color. Here's the punch line, though. The display doesn't actually mix the colors—your eyes do. The monitor shoots tiny red, green, and blue dots, or pixels, on the screen. The resulting colors are pure dots of the three additive primaries, so the color you experience is a mix of those three primaries.

The second type of color is called "subtractive" color, and is created when you mix dyes or pigments in the form of ink or paint. To illustrate the properties of subtractive color, allow me to harken back to my early days as a fine artist; I

guess it was around 1st grade art class, exploring the expressive potential of finger painting techniques.

Start with a clean page. White. In subtractive color, white is the absence of color. (Referring back to additive color—or light—the absence of light gives you black.) As I mix in more paint, my colors get darker and darker. If I mix yellow and blue, I get green. If I add red to that, I get brown. If I keep adding paints, the values go darker and darker until, for all purposes, I have black.

The traditional subtractive primaries are red, yellow, and blue. Any combination of those colors will make any color. As you may remember from finger painting, though, a good clean black is pretty hard to make, so the actual colors of inks or paints used in subtractive color include black. Again, why do we care? Because this is how your printer makes colors (most digital media actually use cyan, magenta, and yellow, because these shades work better with machines to reproduce accurate, lively color), and remember that your printer doesn't actually mix the colors either—your eyes do.

 Here is a macro shot of the dot pattern made by an Epson printer. What you see up close is a bunch of varying size droplets of ink, in what may seem to be an imprecise pattern. On the contrary, this a very precise pattern of droplets of the four subtractive primaries, printed for the sole purpose of giving your eyes the experience of the color you're trying to reproduce.

Interestingly, the early dot patterns from ink jet printers were a regular grid of dots. As they evolved, the dots became a more "random" pattern, a technique called "microweaving," and started to resemble our old buddy, color negative film.

The point here is very simple. Color is perception. An experience.

We have found a way to describe that experience with numbers—much like we describe heat or cold—and we were using those numbers long before "digital" color. We use those numeric descriptions of our color perceptions throughout our digital system, and the purpose of that is to control and manage our perception—our experience—of these colors every step along the way. This book is about that journey of color, that connection and translation of color throughout the process from capturing a color with a camera, to printing the color on a photograph. But more importantly, this book is about your experience of color and how to consistently manage that experience from start to finish.

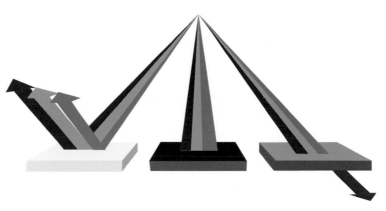

Now that we are on the same page and have established that color is a perception, we must revisit some of the most basic concepts of the science of color. This is all stuff that you probably slept through in science class (I know I did), but we can actually see and use these controls in Photoshop, so we've got to understand where they come from and why they're important.

The experience of color that I'm concerned with as a photographer comes from light, and light is essentially a "radiation" of sorts. That is, it is a wave—an electromagnetic wave, to be specific. Depending on the wavelength, we can either see the color or we cannot. In the visible spectrum, wavelength determines the colors that we see. Here is that familiar chart you may remember from between naps in science class.

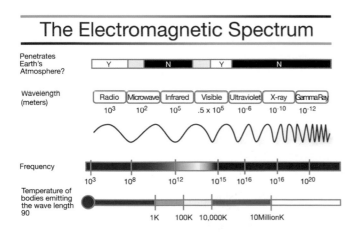

Every color we see, we can see because it reflects electromagnetic waves in that tiny little area shown as visible wavelengths.

This brings us to a discussion of reflected light and transmitted light. The colors we see in a flower garden, for the most part, are a result of the flower reflecting a particular wavelength. When sunlight hits a flower, the flower absorbs most of the colors in the white sunlight. The few wavelengths that get reflected out into the world create the color we can see. Transmitted light is similar, except in that case we're talking about the light that gets to shine through the object. A filter—that same flower petal with light shining through it—will absorb the larger share of wavelengths and allow only a few wavelengths to shine through.

This totally confused me back when I was a kid in school. The colors that are absorbed are not the colors we see. The colors we see are either reflected (bounced back to us) or transmitted (allowed to shine through).

Whether you're talking additive or subtractive color, you're talking about the wavelength of radiation that bounces off or shines through your subject. How I make that wavelength, either by shining colored lights, or mixing

pigments, doesn't matter—what my eyes see is the radiation of reflected or transmitted wavelengths.

RGB Color Relationships

I had my first "Eureka!" moment with Photoshop's three main color channels (red, green, and blue), and then began to understand what everybody was talking about in terms of how colors relate. I always found it pretty confusing that first, we're talking about this electromagnetic spectrum that looked like a bar, and then suddenly we're talking about a wheel.

Hold on to that thought: I'm going to set the groundwork for looking at the three channels

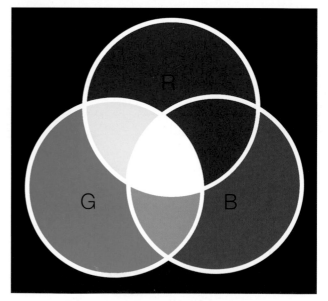

in Photoshop, and how that works.

Look back at the diagram of additive color. You have the three big spots of red, green, and blue light, right? As we mentioned earlier, those are

the additive primaries. Now, look at the areas where two of the primaries overlap. There, where green and blue mix, for example, you get cyan.

Cyan, yellow, and magenta are our secondary colors. And now you have the color wheel.

If it's helpful, think of this entire "wheel" as residing within that bar on our spectrum chart. The wheel is just a visual tool to describe how these colors relate to one another. These separate wavelengths sit inside the "visible spectrum" part of the chart, and we're exploring how those wavelengths interact.

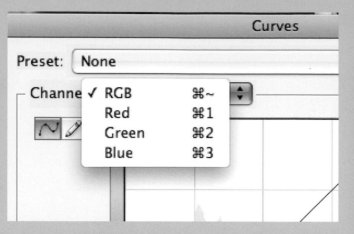

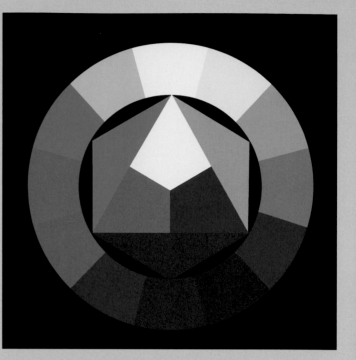

This is where I make the connection to the RGB channels in Photoshop. Go into Curves in Photoshop and pull out the Channel menu. Select Red. Now, by dragging the Curve up, you boost red, right? What happens when you drag it down? Look back at the RGB figure. What is on the opposite side of red? It's cyan, where green and blue mix. When you pull the red curve down, you get cyan.

Each channel does that same thing. Blue curve up, you get more blue; blue curve down, you get yellow (the opposite of blue). Green up, green. Green down, magenta. When you manipulate the individual channels, you are pushing the balance of the color wheel around to one side or another.

The Color Wheel

Here's where this gets a little confusing. We've all heard about the color wheel, and here is a picture of it.

The three main colors in the middle are not RGB; they are red, yellow, and blue. What gives?

It's really simple, actually; this is subtractive color, and red, yellow, and blue are your subtractive primaries. The color wheel for pigments is different than the color wheel for light.

Don't let this confuse you. I point it out for a couple of reasons. First, when you're reading and talking to people about the color wheel, keep in mind the traditional color wheel is for painters, dealing with pigments, and this is what they are probably talking about. We are working with additive color (light) so our color wheel is built differently. In fact, people working in RGB don't often refer to the color wheel.

Second, this traditional subtractive color wheel is something you should keep in mind only to aid your understanding of how colors interact. For example, complementary colors (opposites on the color wheel, i.e. red and green) and adjacent colors (colors next to each other, i.e. blue

and purple) are important concepts to know when working with color.

Another thing: In an ink jet printer (and, for that matter, an offset press), those three primaries are actually cyan, magenta, and yellow (plus we throw in black). The traditional color wheel is fine for painters and for understanding color relationships, but for the machines that print color, the colors that work best are slightly different.

Finally, as a photographer working in Photoshop, you are not mixing paint—you are adjusting color with the RGB model. The most useful thing to keep in mind is that red/cyan, green/magenta, blue/yellow balance.

The Emotion of Color

For all this science, I want to go back to my original concept. Color is an experience. The bottom line in understanding how to use color in your photographs is based solidly on the idea that color inspires an emotional reaction.

Here's a related example. I once read an interesting story on the significance of sense of smell and our memory. Smells, for some reason, trigger some of our most profound and vivid memories. I recently found one of my grandmother's cologne bottles and took the cork out. I immediately was transported back to my childhood memories of my grandmother's house, her face, her clothes—it was a magical experience.

This seemingly disconnected relationship between our senses and our emotions is exactly what is happening with our perception of colors. If we are studying what color does and how to control it, we've got to also understand how we react to it. Colors and their various combinations make us feel things, and part of learning how to use color is learning to recognize how colors make you feel. This affects not just our basic emotions—it affects how we compose an image. The tonal and color values of an image are as important to the composition of an image as the lines, shapes, and arrangement of elements.

Okay, enough of the touchy feely stuff. This process of exploring color is a lifelong path—there has been plenty written about it, and in many cases you can see the path of exploration throughout an artist's life as their work evolves. This is where we see the ideas of palette, "schools" of color (Impressionism, for example), and "periods" in an artist's work. It is not a subject that is restricted to painters—it's something that has a deep significance to anyone making art.

Study photographs, images, paintings, and sculpture, not only in terms of the shapes and lines, but also in the context of their colors and hues—their tones—and think about how that grabs your eye and controls your feelings.

Whint exactly is dpi and ppi? It is simply resolution—and resolution is simply a way to talk about detail. When resolution is higher, the detail is finer.

Look at dpi for a second. Imagine we have 1 dpi, or one dot per inch. This means the dot is an inch in diameter. 10 dpi means each dot is 1/10th of an inch in diameter; ten dots fit into one square inch. 100 dpi? The dot is now 1/100th of an inch—100 dots fit into one square inch.

Say you want to print an image that is one square inch, and you have 10 little spots in it. You need a resolution of at least 10 dpi (dots per inch) to print those spots.

Any resolution description amounts to a certain count of "somethings per inch." The silly part is that various "somethings per inch" are used to describe different things in different places. Take pixels, or ppi, for example. In Photoshop, pixels are small squares of color, and we use ppi to determine our print size. The monitor also measures resolution in ppi, except these pixels are little spots of light—it is a completely different thing with different ranges and meanings.

Here's a quick list of a bunch of resolution yardsticks and where they are used, in no particular order:

LPI: "Lines per inch" is used in offset printing. Back in the days of film, offset printers would shoot a photograph with a big graphic arts copy camera to break it up into dots the press could reproduce. You'd use a "screen" to do this, and a 165-line screen would give you 165 dots per inch. Ironically, this is the only place you ever actually see dots per inch, and they call it "lines per inch."

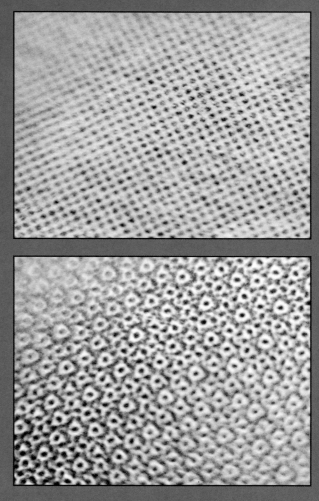

DPI: "Dots per inch" is used in offset printing. (See above.)

DPI: "Dots (droplets) per inch" is used in selling ink jet printers. Ink jet printers don't really make dots—they spray droplets. The 720, 1440, and 2880 "dpi" rating of most ink jet printers only vaguely resembles what actually comes out of the printer, considering the droplets are sprayed out at an irregular pattern (called microweaving) and at varying sizes. The droplet capability of the printer is more accurately measured in the minimum picoliter

volume of the droplet itself, currently around 4 or so. (A picoliter is a very small part of a liter.)

PPI: "Pixels per inch" is used in Photoshop. Pixels, in Photoshop, are squares of color, usually described by the three basic channels—red, green, and blue. The image size, or how it will ultimately be printed, is specified in the "Resolution" part of the Image Size dialog. I usually use 180 ppi for printing to an Epson ink jet printer.

PPI: "Pixels per inch" is also used in describing monitor resolution. The concept is the same, but the "pixels" we are working with are completely different. Pixels in a monitor are small points of red, green, or blue light. Your eyes (actually your brain) take the three primary colors and mix them to get all the colors the display is able to recreate. The pixel dimensions of an Apple 30 inch display is 2560 x 1600 pixels. The dimensions of the display are roughly 21 x 27 inches, so that figures to about 80 ppi. (Contrary to common practice, the display resolution is almost never the 72 ppi that people always suggest.)

PART 2

LET'S GET DIGITAL

n order to work with color in a digital medium, you must have a way to translate that color into digits (otherwise known as, well, "math"). That is, there has to be a way that you can convert the sensation of color into numbers, but also, numbers that can work in some sort of framework.

CIE XYZ and CIE LAB

In 1931, the CIE (International Commission of Illumination; very active even today—the US website is www.cie-usnc.org for some scintillating colorimetry reading) developed a couple of methods to measure color. Based on human perception, the CIE developed CIE XYZ and CIE LAB spaces, based on a "tri-stimulus" model similar to the human eye. "Tri-stimulus" is simply a way of saying there are three stimuli. In the case of the human eye, we're talking the short, middle, and long wavelengths from the three cone sets in our retinas. (Refer to the

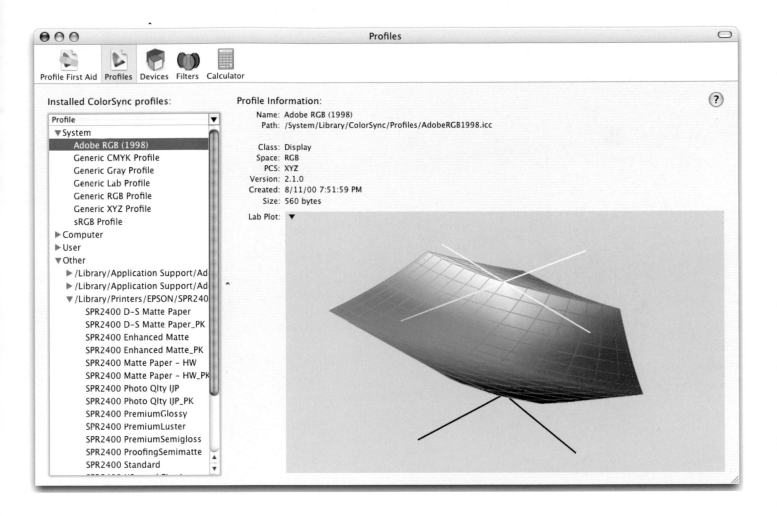

color wavelength illustration on page 25.) The CIE decided it was better to use roughly red (X), green (Y), and blue (Z), in the case of CIE XYZ; and lightness (or luminance; L), a range from red-magenta to green (A), and a range from yellow to blue (B), in the case of CIE LAB.

This is simply a method for quantifying our sensory experience of color. Think of temperature again—by developing a device that can quantify temperature (a thermometer), we can answer the question, "How cold is it?" By developing this description of color, we can describe colors in a consistent, objective, and mathematical way.

This gamut map shows the model in action. You can see gamut maps for color spaces by going to the Apple ColorSync Utility (Applications>Utilities) and selecting "Profiles." There, you can load various profiles and take a look at them as actual volumes—spaces—that you can rotate and compare. Here's an example of the Apple ColorSync Utility showing AdobeRGB 1998. You're looking at the AdobeRGB color space "plotted" or "mapped" on the LAB color dimensions.

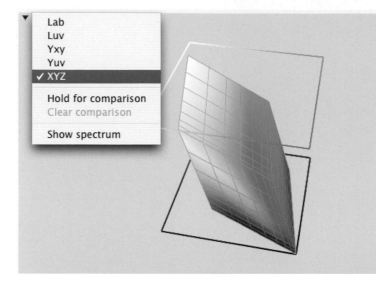

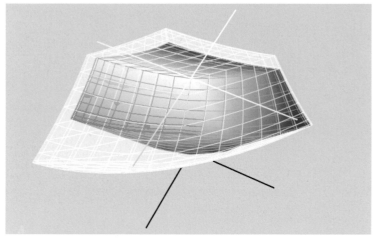

Here's what it looks like when I switch it to the CIE XYZ dimensions. We've just changed our yardstick. Now we're using different sets of units to measure and graph the same "space."

What I've done next is used the "Hold for Comparison" feature, allowing me to compare and contrast sRGB with AdobeRGB 1998.

Stop. Right in front of you is the secret and the elegant simplicity of color management. What is this exactly? We are visually comparing and contrasting two descriptions of color using numbers. If we were really cool,

(which, of course, we are) we could take those comparisons—because after all, they are mathematically generated graphs—and calculate the difference between the two descriptions. We're using CIE LAB and CIE XYZ as a way to mathematically compare and calculate conversions from one space to another.

What you're looking at is the use of LAB and XYZ as a "Profile Connection Space," illustrated by the use of a gamut map to visualize the differences between spaces. Hold that thought; we'll come back to it.

I'm going to switch utilities here and show you a great program called Chromix ColorThink (www2.chromix.com). I use it mostly to make gamut maps, but it has one important feature that the ColorSync Utility does not—it allows me to plot the actual gamut (the actual colors) of an image, and not just the profile. Here's a shot of a photograph plotted on the LAB dimensions, with AdobeRGB in the background.

The image shows up as little dots of color and displays the colors from the image as they fall on the space. This allows you to visually inspect the image and make some interesting conclusions about it. For instance, this photograph does not have a lot of deep blue. It doesn't look very balanced or full—it shows mostly reds and yellows.

I'm able to see the image colors on this "graph," so I can make conclusions about it that are visual, but also, at the root of it, mathematical. Using this program and the LAB or XYZ plot,

I can view and compare any of the color gamuts from any of the devices or spaces that I'm working with. Again, we'll come back to that thought.

The process of managing colors is just as simple as that. Describe the colors in a mathematical way. "Connect" them using a comparison tool, specifically, a graph. Calculate the differences between them, move them around to fit, and go to the next step.

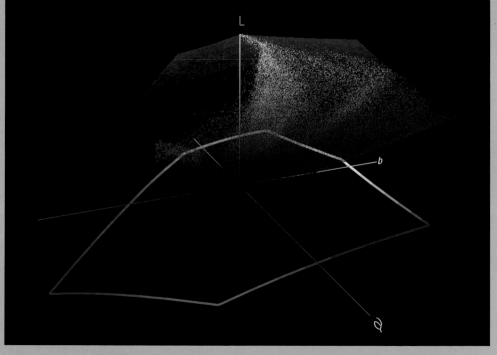

The Working Color Space

The first idea I want to clarify is that of "device dependent" or "device independent" color. For all the lengthy descriptions and explanations of these terms, it boils down to a very simple thing, explained in the glossary of *Real World Color Management*, by Fraser, Murphy & Bunting.

Device-dependent color is when you have a "color model" where the numbers you use to describe color (RGB, for example) are different from device to device. If you give six different, un-calibrated monitors the same numbers, they will make six different colors. The color depends on what machine produces it.

Device independent color is when the color model handles the numbers describing the colors "universally," not in the context of a device. This is where we see the "working color space." The working color space establishes a description of colors in an objective way. Once we have that objective description, we can connect all the various devices we have to work with, translating colors from our cameras and scanners into our working space, translating that to our display, and then to our printers.

The working color space does this by building some basic controls into its framework. More than just describing red, green, and blue values, a working color space has a volume—or

limits—to what it contains. (Think of a box of crayons—there is a fixed number of colors to work with.) In this figure, you see the basic settings in a color space. The "Primaries" are the settings that define your R, G, and B values. (You can find the specifics of any color space by going to Edit>Color Settings and selecting an RGB space in the "Working Spaces" window.

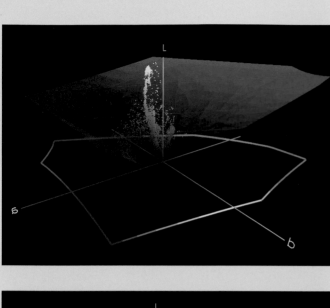

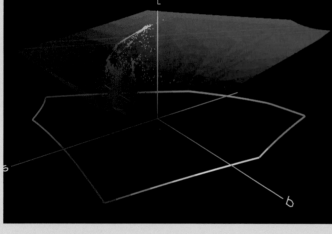

Then, pulling the same window down, select "Custom RGB." It will display the above window, based on the space you started with.)

White Point

For me, the "white point" is the most interesting control. It is what I describe as the anchor of a color space. It is one of the main elements that set the description of colors independently, and not in relation to a device. I set the white point—or the neutral balance—and then map the colors in my working space around it. That is one of the ways I teach RAW file processing. One of the essential steps in the process is to handle these random colors coming from the camera's sensor, and the way you do that is to establish what is neutral gray. You then "map" the colors from the sensor around that point, according to what you know about the camera (defined by the camera's "profile"; see page 101 for more on camera profiles).

Here's a visual. This is the gamut map—a chart showing the actual colors from a photograph, mapped on the three dimensions of L, A, and B (more about that on page 187), along with a map of our working space, AdobeRGB 1998. There are two photographs shown, but both are from the same RAW file. One RAW file, the "normal" color, was processed using a daylight—or 5500Kelvin (K)—white balance. The other blue image was processed using a

tungsten—or 3700K—white balance. You can see from the gamut maps that the distribution of colors is roughly the same shape, but they are centered differently.

The working color space has an "absolute neutral core" of 6500K for the "white point" setting, as we saw above. We see that expressed as 6500K—or D65—and we also see it has a specific "x" (.3127) and "y" (.3290) designation. This is the anchor of our color space—the core of white on our graph. The colors from our device, our camera, on the left, map a little to the warm side of that "core,"—most of the colors are in the red/magenta range. In the right image, the colors are mapped to the left of the core 6500K, into the blue range. We've set the neutral values of the image, and they are being translated according to that neutral value, taking the colors out of the

context of our camera and placing them into a "universal" description.

Gamma

Gamma is one of the most annoyingly confusing terms in the whole color management glossary (and one of the terms I love to hate). It's basically been glossed over in almost every explanation I've heard or read, but appears just about everywhere in the process. If you didn't know better—and why should you?—you may think the gamma you see here is the same "gamma" you see in the dialog window for some monitor calibration software, in some printer drives, and a whole host of other places. I've even gotten into arguments about it; gamma is gamma, comes the hue and cry! Printer gamma is the same "gamma" as display "gamma."

It is, but it is not. Temperature is temperature, right? Whether we're talking about degrees Fahrenheit, Celsius, or even Kelvin, or hot or cold objects, temperature is all the same thing. Temperature is simply a way of describing the degree to which something is hot or cold.

Strictly speaking, gamma is simply a relationship between input and output. So, yes, gamma is gamma, but the input and output of a printer is very different than the input and output of a monitor. So, like I say, gamma is gamma, but it is not.

Let's take a few steps back and look at gamma. Here is the equation for monitor gamma (settle down, this won't send you screaming back into your math anxiety flashbacks—I hope). "V" is your signal. Ready? $V^g = V$. How bad is that? "V^g" is your input; "V" is your output. Your output is the "g" root of your input. (It's okay, I'm almost done.) Suffice to say, your gamma—or your input/output—is a curve. The numbers you get from this equation are what ends up as 1.8, 2.0, and 2.2—depending on what you plug in. Measure the input, measure the output, plug them into the equation, and get the result.

Think of it like this: the gamma of a device, or a space, is the space's contrast curve. Even more simply: gamma is contrast.

The really important thing to take away from this, just in case your eyes started glazing over a few paragraphs back, is that the gamma

numbers you see throughout the process—1.8, 2.0, or 2.2, for example—are talking specifically about that one single thing, and are not applicable throughout the system. The fact that you are using AdobeRGB, which has a gamma of 2.2, has no bearing on the fact that your display is calibrated to a gamma of 2.2. They are describing two completely different things.

How do I use gamma in color management? I set the "gamma" selection at 2.2 when I calibrate my monitors. That's it. My video card and my monitor have a gamma of 2.2, regardless of the so-called Apple and Windows "standards."

That brings me to a story to loop us back around to "Life After Color Management." It's my Bill Atkinson story. Bill was one of the early members of the Apple team, and developed QuickDraw and MacPaint. I had a chance to meet him in his studio, listen to him talk about color management, and to ask him some very specific questions. He patiently answered them all. We were talking about the 1.8 versus 2.2 gamma "standards," and I asked him why Apple made that specification. He said it was "the silliest thing;" they were working on the first laser printer, the Apple Laserwriter, and could not get the print to match the values on the screen for the life of them. This is in black and white, mind you. So they adjusted the output of the video card to 1.8. He laughed. They couldn't fix the printer so they changed what they sent to it.

This is exactly my point. At that point in time these guys were just trying to get this printer to

work, and printing color, much less color management, was not even a thought. In spite of this arbitrary adjustment and in the face of the actual measurements of gammas around 2.0 to 2.1 on Macs or PCs, you can still hear the arguments from all corners about the Mac and PC standards—and the resulting confusion from those arguments.

There were a lot of missteps and confusion surrounding the birth of this new medium, and it's time to pay our respects and move on.

Choosing a Color Space

A host of questions arise regarding the choice of one color space over another, and we will be

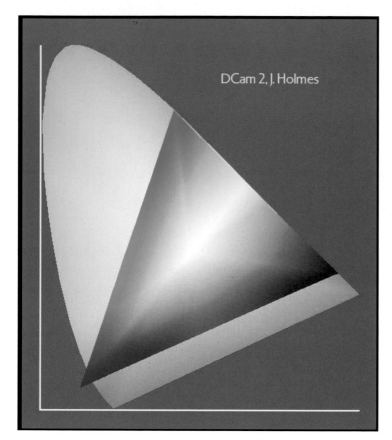

DCam 2, J. Holmes

Here is a gamut map of Joe Holmes' space "DCam2," and a short explanation of it from his site: "DCam 2 is a superior alternative to Adobe RGB with far better efficiency at encompassing real-world colors, including subject and printer colors both. It's an ideal choice for a general-purpose digital camera capture RGB working space when the photographer tends to avoid very saturated subject colors and wants to optimize quantization efficiency."

going into specifics later on, but let's get the basic idea. Think of it in terms of a tailor laying out a pattern.

The first and most obvious problem is trying to work in a color space that is too small. The tailor lays out his pattern on a kitchen table, and big parts of it are falling off the table. The tailor is constantly pulling and pushing the cloth around to get it on the work surface. If you're using a color space that is too small, you're going to have colors that fall outside that space, and you're going to have to figure out how to avoid simply losing them. You are also going to have to "scrunch-up" the colors—compress them into that tiny area. You should be working in a color space that is big enough for your range of colors. (For general photography purposes, this would be AdobeRGB 1998, in my opinion.)

The second and less obvious problem is using space that is too big. This is an issue of "workability" among other things. The tailor spreads out the pattern on a table that is huge. It doesn't fall off the edge anymore, but now he can't reach parts of it. Working in a huge color space—like ProPhoto RGB—creates the same problem. The space is huge—much larger than what the monitor can display. It becomes difficult to even view the colors, much less work with them. Beyond that, the colors get stretched to fit within that space (to put it in very unscientific terms). Let's just say they are altered and for no good reason.

Beyond that, you have what Joe Holmes—a friend, color scientist, and photographer who has done an incredible amount of great work helping the understanding of digital color theory—describes as "working with discipline" within a practical color space. Why waste time developing and adjusting a color to a point that it completely falls outside of our workable gamut? It's just going to have to be adjusted back in. It's a much better, cleaner and more efficient way to work within the "discipline" of your most efficient color space. You work faster, do less damage to the colors, and, by streamlining the process, allow yourself to do what I harp on continuously—visualize!

Simplifying the process allows you to work in a pattern. A pattern lends itself toward developing a habit. A habit allows you to anticipate results, and anticipation teaches you how to visualize your final outcome.

Joe has gone so far as to develop a series of digital camera working spaces—spaces ideally suited to working with colors coming from the sensor and the RAW processor. (For more information, and a great explanation of all this from his perspective, see his site at www.josephholmes.com.)

I've read in a few places that the .jpg format should only exist in the sRGB color space. The argument has been that because of the compression and format issues with that type of file, colors in AdobeRGB 1998 simply get dumped. Well, ColorThink and I are here to say, "Hogwash!"

Here is a gamut map of a .jpg file processed from a RAW file, to the AdobeRGB 1998 space. I made the graph blue.

Here is the exact same RAW file processed to a .tif, which I'm showing here in red.

Here they are together.

Here they are with the AdobeRGB space shown very lightly, and the sRGB space shown as the opaque overlay.

You can clearly see from these images that there are colors in both the .jpg and the .tif gamut maps that sit outside the sRGB space, and that the .jpg colors are almost identical to the mapping of the .tif.

So there. A .jpg can be used with AdobeRGB.

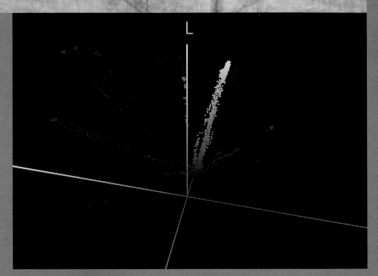

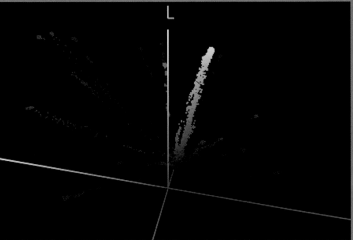

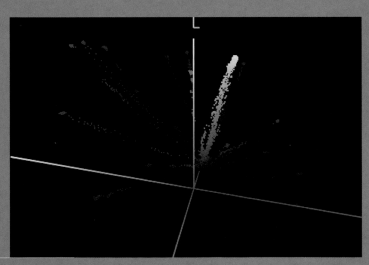

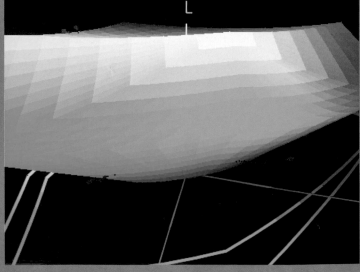

Where Does Color Come From?

Colors in digital photography come from the pixels on the sensor, and pixels are simply tiny light meters that convert light energy into electrical energy. As a certain intensity of light hits the pixel, it creates a certain amount of voltage. (Here's another little point of confusion: the pixels in a sensor are not at all the same things as pixels in Photoshop. Photoshop pixels are little squares of RGB color, and pixels on the sensor are little wells in a silicon wafer that are photo-electrically sensitive.)

Left alone, the pixel gives you a voltage reading that corresponds to the brightness of the light recorded by the sensor on that one spot, right? This is simple luminance, and won't tell you anything about the color of the light on that point. However, suppose I place a red filter on that tiny light meter. Now I have a luminance

reading for only that color red. Bingo.

Go back to the idea that you have the three basic primary colors in additive color (color made with light rather than pigment)—red, green, and blue—and you have the start of a color-encoding plan. The plan breaks down like this: take a little group of pixels, give them red, green, and blue filters, and the pixels generate voltages for red, green, and blue channels, corresponding to the intensity of that particular channel at that specific location. Add to that one more bit of information—the overall brightness of the tone; that is, it's position on a range from black to white—and we can now make some decisions about digital color.

 The basic array measuring color information on the sensor is the red, green, green, blue pixel group, shown here. The red, green, and blue pixels give you R, G, and B information; that is pretty obvious. The second G pixel is used to generate the luminance information, because a green pixel reads luminance in a very similar way to how we perceive light and dark with our eyes and brain.

The sensor is comprised of many of these basic groups; these arrays, or groupings, each create voltage readings in an interlaced pattern of red, green, blue, and luminance. I call it the RGBL array. It is then used by RAW processing software to build the RGB information for the pixels in Photoshop.

So far, our information is still measured in volts. The first step to making sense of this is translating those volts into digits, and that is done on a scale of 0 – 255 (for an 8-bit file). The black value is set at 0, the white value is set at 255, and the rest of the image is mapped into 253 steps of red, green, or blue, and luminance. The "Analog to Digital" (A/D) converter performs this function. We now have a file that is the true, digital, RAW image file.

The RAW Processor

Here's where things get a bit unpredictable.

Bruce Radl of Mosaic Imaging, a very patient man with a good sense of humor and tolerance for dumb questions, who has devoted his life to the science of processing RAW files, helped me out once—well, more than once, to be honest. This particular time I was trying to figure out the exact process from the RAW pixel information to the Photoshop image ("de-mosaicing" the file). Bruce explained that it was simply a matter of taking one image made up of individual red, green, and blue pixels, and making an image made up of RGB pixels. That is, the RAW file has pixels that are individual primary colors

Living as I do, in my rather insular world of photography, I thought the way a digital image is constructed in Photoshop (made up of pixels, or squares of colors, and determined by the values of 0 – 255), must be limited to Photoshop. It never occurred to me that other, non-photographic systems use this conversion method. It never dawned on me that this is the standard amount of "levels" in any 8-bit digital conversion.

Then I had a chat with my mad inventor friend, David O'Brien, who is building a little device that flashes LED lights in response to a stimulus. (Sorry, I can't tell you any more—I'm sworn to secrecy.) He was talking about how his voltage is translated by an A/D converter into values of 0 – 255, then his microprocessor works on the data. Wow. Okay. He wasn't talking about pixels, or Photoshop, or anything related to imaging. He wasn't even talking about computers, for that matter.

This is what I discovered: any 8-bit analog-to-digital conversion translates any input signal into a numerical value in a range of 0 to 255. That's the beginning and end of it.

The zero value is generally set when the device is at zero. Zero volts mean a zero value. The top end of the device is 255. If you have something that generates 12 volts, the 12-volt value would be 255. Let's say our 12-volt device is only making 10 volts. Our A/D converter would tell us the device is putting out around 210.

The key is to make sense of that "210" value. By first linearizing the device, you are ensuring there are no "bumps" in its response. By adjusting the baseline and the range, you are placing the device on a useful spot in the 0 – 255 scale. (See page 100 for more on Linearization.)

Any device that "digitizes" its information applies this process to its signal to create digital information. This is not limited to pixels.

(sensor pixels). The processed file is made up of pixels that contain a combination of the three color channels (Photoshop pixels).

To do this, the RAW processing software must combine the R, G, and B information for each cluster of four pixels (the RGGB sensor array), and determine what balance and value the "virtual" RGB pixel has to be. The software will, at its most basic level, determine a neutral point and map colors around that. This is also where you set the final black and white points in the tonal range of the image and map how the midtones fall between the two extremes. This becomes the contrast curve. The RAW processor also decides how many pixels to build, where they need to go, and how to define edges and borders. These are the three basic functions of the RAW processor: color, contrast, and scale; everything else is a happy extra.

Back to our little pixels, and their new digital

color information. How does the RAW processor know what to do with these colors and tones? This is where it becomes unpredictable; it depends on the camera make and model, the files themselves, the RAW processor you're using, and—to some extent—where you decide to do what. In the broadest terms, however, the following is what happens. The image file's metadata contains all sorts of interesting information, like what camera shot the file, how the camera was set, and what specific processing instructions to use.

Here's the basic information, under File>File Info in Photoshop. Adobe Camera RAW can see that this is an Olympus E10, shot at ISO 80, along with a whole host of other information about the camera. Camera RAW then chooses and applies a standard "profile" according to this information. The color profiling that any given RAW processor uses depends on a lot of things: the type of camera sensor, how the file is encoded, and whether it uses a specific profile for that file or a "canned" profile for all cameras. For example, a DNG file that has been converted using Adobe Lightroom will have the previous Camera RAW settings all built into the metadata. It will look like this.

For the sake of argument, suppose we are using a Leaf Aptus 22 with the Leaf software. With that particular workflow, there are very specific camera profiles in the RAW process, which will render the colors and contrast in a wide array

P2163591 as Smart Object-1

Description
Illustrator
Adobe Stock Photos
IPTC Contact
IPTC Image
IPTC Content
IPTC Status
Camera Data 1
Camera Data 2
Categories
History
DICOM
Origin
Advanced

Camera Data 1

Make: OLYMPUS OPTICAL CO.,LTD
Model: E-10
Date Time: 2004-02-16T08:44:51-05:00
Shutter Speed: 1/125 sec
Exposure Program: Aperture priority
F-Stop: f/8.0
Aperture Value: f/8
Max Aperture Value: f/2.0
ISO Speed Ratings: 80
Focal Length: 17.0 mm
Lens:
Flash: Did not fire
No strobe return detection (0)
Unknown flash mode (0)
Flash function present
No red-eye reduction
Metering Mode: Pattern

Powered By xmp

Cancel OK

P2163591 as Smart Object-1

Description
Illustrator
Adobe Stock Photos
IPTC Contact
IPTC Image
IPTC Content
IPTC Status
Camera Data 1
Camera Data 2
Categories
History
DICOM
Origin
Advanced

Advanced

▶ XMP Core Properties (xmp, http://ns.adobe.com/xap/1.0/)
▶ Dublin Core Properties (dc, http://purl.org/dc/elements/1.1/)
▼ http://ns.adobe.com/camera-raw-settings/1.0/
 crs:Version: 4.2
 crs:RawFileName: P2163591.ORF
 crs:WhiteBalance: As Shot
 crs:Temperature: 5600
 crs:Tint: +18
 crs:Exposure: 0.00
 crs:Shadows: 22
 crs:Brightness: +50
 crs:Contrast: +25
 crs:Saturation: 0
 crs:Sharpness: 25
 crs:LuminanceSmoothing: 0
 crs:ColorNoiseReduction: 25
 crs:ChromaticAberrationR: 0
 crs:ChromaticAberrationB: 0
 crs:VignetteAmount: 0
 crs:ShadowTint: 0
 crs:RedHue: 0
 crs:RedSaturation: 0
 crs:GreenHue: 0
 crs:GreenSaturation: 0
 crs:BlueHue: 0
 crs:BlueSaturation: 0

Powered By xmp

Replace... Append... Save... Delete

Cancel OK

of "looks" when applied to the RAW file. These profiles have to "connect" to the RAW colors. They do so using the same "connection" strategy that the rest of the color management system uses—plotting the RAW colors and the camera profile to a graph (usually in RAW software), and then connecting the colors by calculating the mathematical differences.

Once you're there, the RAW software allows you to edit the colors yourself—that is, manual adjustments to suit your taste. A good color-managed software package will have a connection to the display as well, so that it accurately displays the colors that the software is working with. (This is much the same issue that scanner software has, too, by the way, and why, with

most scanner software, you have the choice of selecting and applying a display profile.)

Finally, we process the file into the working color space we've chosen in Photoshop. You guessed it: we have to again "connect" the colors, and again we use our CIE XYZ "description" to size them up and convert the processed file to live within AdobeRGB.

Where Does Color Go?

Sending the colors to the printer is the first real step outside of the world of light. Up until now, all our colors have been made up of our red, green, and blue additive primaries. First, we're dealing with additive color (think back to our additive and subtractive color discussion; or refer to page 21).

Now, we have to take these little squares of light—our Photoshop RGB pixels in our "absolute" space of AdobeRGB—and somehow make them into ink droplets on a piece of paper. As I've hinted, the first step is to figure out what the printer does (in RGB terms), and "connect" the colors from the

working space to our device, or printer space. In this case, we're going to use LAB as our "profile connection space" because it works better. Think of it in terms of inches and centimeters— sometimes it's better to use centimeters, because they divide and multiply so easily. LAB just gives you a better "handle" than XYZ when working with a printer device profile.

In Photoshop, select File>Print; it takes you this dialog. First, you are still in Photoshop. Second, we've selected the "Color Management" option, and we get the Color Handling and Printer Profile drop-downs. Here is where we map the colors from AdobeRGB to the printer/paper "device" profile. We're still in RGB, right?

Next, select "Print." This takes you to a series of screens that are "OS" dialogs, that is, part of the Operating System of the computer. The

screen shown on the following page is from Leopard, (OS 10.5.1), "Panther" has it, Windows XP has it, and I'm sure the next big cat (Tabby?) will have it too. These screens are the printer driver. They do not deal with RGB color management; they deal with the mechanics of running the printer. It is here that our happy little RGB pixels are screened, dithered, and microweaved. It is here that the printer is told how much ink to put down for the paper you're using.

Basically, the red, green, and blue color squares of light are converted into cyan, magenta, yellow, and black droplets of ink and sprayed on the paper. How these droplets are sprayed determines how the colors will look on the page—a higher ink dot concentration means a darker color.

These drivers also have a built-in "color control." Generally, it is just a band-aid to help the system print well in an unmanaged system—unmanaged color system, that is. Since you've already corrected the file in its RGB state, we don't need to use this driver control.

You may wonder—if the printer is working with colors in CMYK, with ink—why we don't go to the CMYK mode in Photoshop, save the drivers the work, and control the output from there. That's a good question, and, in fact, in a prepress workflow you may decide to do that. However, the drivers in an Epson printer—or any other photo-quality ink jet printer—are

built to accept an RGB file. So much so, that if you feed them a CMYK file, they will convert the file to RGB first and then stuff it through the process. This is not a good thing for our little colors—it is one more unnecessary conversion step and can be destructive.

If you want to look at the inner workings of a printer driver, look at the advanced controls in any RIP. I'd point you towards Colorburst, or Imageprint (Colorbyte), but it doesn't really matter which. In any RIP you can get to the various deep-level controls of the printer-screening, dither, ink limits, and even drying time. (More on RIPs on page 96.)

The point to take away from this is that we are changing the very way we are talking about color. We have moved from light (additive) to ink (subtractive).

COLOR JOURNEY OVERVIEW

Planning the Trip

We've gone over most of the important components of the digital color management system. It is crucial that we see how the whole thing fits together, and that is best done by showing the journey colors take from start to finish, from the subject of a photograph to the final print. Let's start with a flowchart, and follow up with a step-by-step example of each part in the process.

First, the flowchart. This shows each step, what the process is, and where it happens.

COLORLAND:
COLOR'S JOURNEY FROM SUBJECT TO PRINT

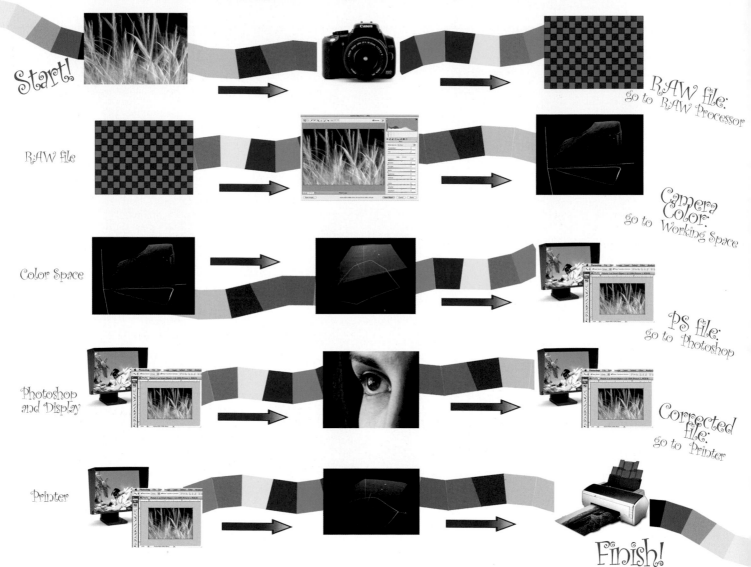

(Line 1) In our color journey, we start by capturing the latent image using a digital camera, connected by light, to create the RAW file. (Line 2) The RAW file is the basis for creating the image in Photoshop using the CIE XYZ color space as the connection, and is built with RAW processing software. (Line 3) Next, from the RAW file in Photoshop, we place the colors in a working color space using the operating system's color management module (CMM) from CIE XYZ, and we display the colors from the color space on the monitor, also using the CMM and CIE XYZ. (Line 4) From the display, the user edits the image, adjusting the image according to how they want it to look. (Line 5) Finally, from Photoshop the user creates the ready-to-print file by remapping the image colors from the final RGB image to the CMYK printer—connected by CIE LAB— to the print driver.

The Color Journey: Tracking the Color Path

The challenge of working with colors comes in two parts: first, we must describe the colors; then we must "connect" them. We use a basic mathematical model of color to do this, a "graph" in three dimensions. We have two basic graphs we use, one that uses X, Y, and Z dimensions, (CIE XYZ, which describes the red, green, and blue values that our eyes can see), and the other using L, A, and B (CIE LAB, which defines color in terms of Lightness, channel A (the red-magenta range), and channel B (the yellow-blue range). We can use the two graphs to make decisions about how to work with colors. Follow the journey of three colors in a photograph, from their start in a grassy meadow, through ColorSync, and to the final print.

Our colors start out in the great wide world—"burple," green, and brown. (Burple, or blue/purple, is in the background as a little tiny spot of color from a blooming iris.) The light hits the camera's sensor and the RGGB pixel arrays record the intensity and color of the light.

The colors are measured by the pixel arrays on the sensor for red, green, and blue values, as well as brightness. The values, in voltage, are translated to numbers in the A/D converter, and now we can work with them in the RAW software.

I have again generated these gamut maps from a program called ColorThink. They are indispensable tools for visualizing exactly how color management works.

(A) Here are the colors mapped on the CIE XYZ dimensions in the RAW conversion software.

(B) Here is the mapped camera profile from the RAW conversion software on CIE XYZ. All three of our colors fit within the camera profile, so any adjustment to them is pretty much unnecessary, although the profile may change the contrast or saturation, depending on what look is intended for the final outcome.

At this point, I'm probably going to do some adjustment to the image in Photoshop—this may or may not move our little guys around a bit. Let's say, for simplicity, it doesn't move them much.

(C) I've turned the camera profile green to help clarify the graph, and now we map the AdobeRGB gamut—our working color space. (You can see its magenta section peeking through the camera profile mapped in green.) The working color space—AdobeRGB—is still in the RAW software and still in CIE XYZ.

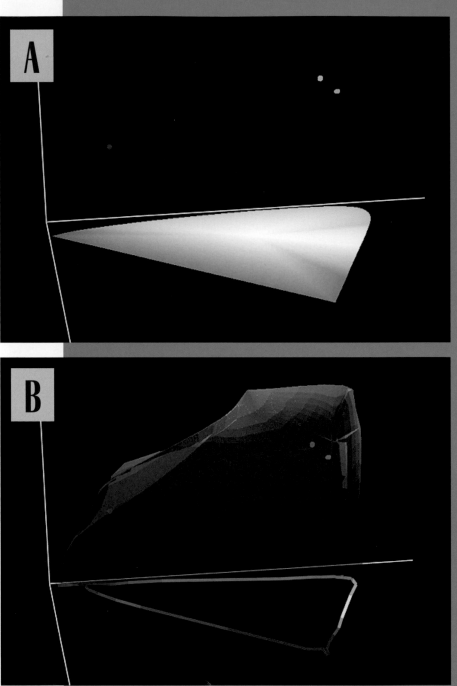

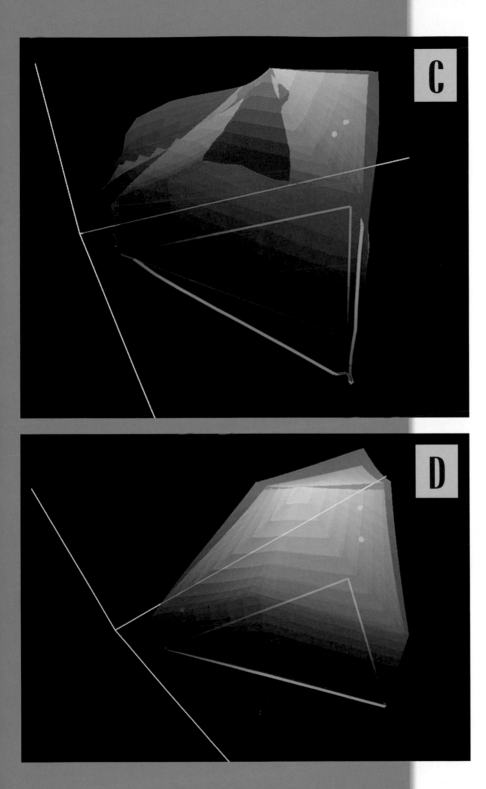

Our little colors will be moved around a bit, but they basically remain the same. They stay in the same positions on the CIE XYZ graph, and they are about the same in relation to each other. In the RAW software, I use this to map the differences, "connect" the color models, and convert the file to a Photoshop image, mapping it to AdobeRGB, my working color space in Photoshop.

(D) Now comes a two-part process. Photoshop has to decide how to display these colors on my monitor, so, again using the CIE XYZ dimensions, we plot the colors, AdobeRGB (shown in blue, for clarity), and the monitor profile (smaller and shining through the blue shape with a little sliver of yellow).) Again, we use the CIE XYZ dimensions and descriptions to mathematically "connect" the colors. I can now see my little colors on the monitor and adjust them accurately and accordingly in Photoshop.

Adjusting the image in Photoshop would move our colors around, depending on how I push the colors. I've moved green over to blue a bit, using my Curves adjustment layer,

but you can't really see it.

The second part of the process from the AdobeRGB space is to send the colors to the printer. First, we must see how the printer can handle our colors, and then the printer does the rest. It converts the little points of colored light into dots of cyan, magenta, yellow, and black pigment.

My first step is to change my "connection" method. CIE LAB works better here than CIE XYZ (for what reason, I know not), so we simply change the graph, or model.

(E) Here is the exact same image, mapped on the CIE LAB axis, and showing just the working color space—AdobeRGB—and our little colors.

Once we have the color space plotted in LAB, we need to see what the printer is going to be able to print. We do that by plotting the printer profile for the paper we're going to use.

(F) Here is my AdobeRGB space, showing the Epson Premium Luster paper profile inside and in true colors.

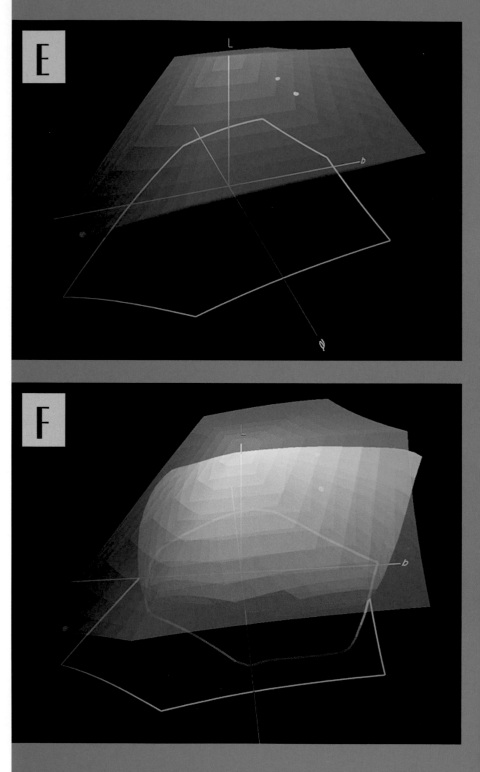

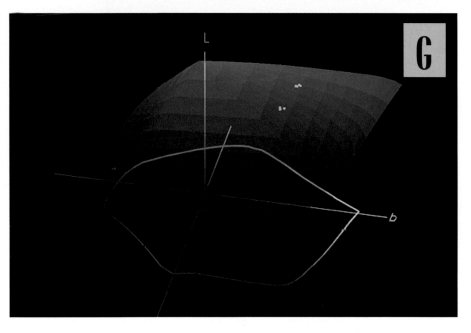

Color Handling: Photoshop Manages Colors

! Did you disable color management
in the printer dialog?

Printer Profile: SPR2400 PremiumLuster

Rendering Intent: Perceptual

G

We can very clearly see that we have one little point of color that is outside our Epson Premium Luster gamut. For the first time, we have to address a real "conversion" or remapping of the colors, and here is where the "Rendering Intent" comes into play. What are we going to do with burple? The little guy has come this far, only to be left off the bus at the last stop.

The various Rendering Intents do things differently, but for now let's say we are converting this file to the Epson Premium Luster profile using Perceptual Intent. (This is done in the Print dialog, shown here.) That will move burple into the printable color range (our gamut) and adjust the other colors to retain the same relationship to one another—the same "perception."

How does this work? Simple math. Our burple, remember, is on a graph of three dimensions, so it has three numbers describing it—400, 500, and 600 (I'm making those up for example sake). Our printer color space has a range it can tolerate that is within those three dimensions—300, 400, and 500 is the closest color to burple the printer can print. Here is the simple math: take burple and subtract 100, 100, and 100. Now you have a printable color.

Another option is to do it manually, and this is possible. In Photoshop adjustments, using "gamut warning" and something like "hue and saturation" for example, adjust burple into the gamut of the printer. If I do that I can map it just how I want to, rather than let the machine map it. Remember, adjusting the colors in Photoshop moves them around on the graph. (We will address this in greater detail on page 170.)

(G) Here's how the colors look remapped to fit our printer profile. I've turned AdobeRGB off so you can see it more clearly. The burple now fits nicely within the printer's color range, and you can see that our single points of color have now become clusters of color—this is how the

Rendering Intent and the "color engine" account for remapping the colors to fit.

The last task is to take these colors and again convert them, except this time we're moving away from the realm of light. We must send these colors to the printer, and the printer uses ink—specifically cyan, magenta, yellow, and black (CMYK)—to recreate our little points of color on paper. That conversion is based around the process of "dithering," or breaking up squares of color (pixels, in our image) and turning them into droplets of color inks. This is usually done by the printer driver, but can also be done by a RIP, which takes over a lot of the functions of the basic printer driver.

Our little colors are finally home, back from a long journey that started with shining in the sunlight off a flower, to shining off of a piece of paper. Our goal is to ensure they arrive intact, accurate, as we initially visualized them, and none too worse for wear.

ColorSync is the Apple Color Management engine. It is built into Apple's operating system, and controls how the computer is going to process, display, and interpret color. Interestingly, in terms of color management, it was the first attempt to deal with color at all—well before the Windows systems even thought it was an issue—and is arguably still the best choice for color management.

(The Windows version of ColorSync and gone by a few names—Windows Image Color Management (ICM) to name one.)

ColorThink, on the other hand, is a color management tool developed by Chromix (www.chromix.com). Primarily the work of Steve Upton, it is a simple, but powerful tool for understanding and manipulating color profiles and connections. ColorThink is the tool I've used here to graph profiles and the colors in images. You can also use it to edit the actual profiles.

Finally you have the Apple ColorSync Utility. This is a free program found in your Apple system under Applications>Utilities. It also allows you to graph and edit profiles, but is not quite as powerful or versatile as ColorThink. It is just a cute little program that is Apple's version of ColorThink.

This is what it looks like, in the "Profiles" mode.

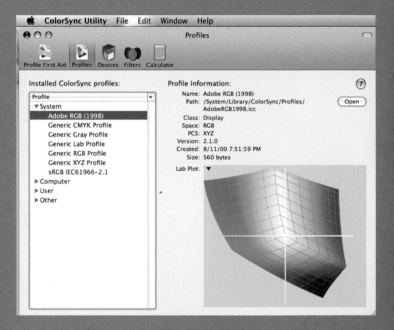

Confused, yet? It's simple really. ColorSync runs the system. ColorThink (and the ColorSync Utility) are tools to understand and manipulate how ColorSync will handle the profiles.

PART 3:
THE DIGITAL DARKROOM: CREATING YOUR PERFECT VEHICLE

Now that we have a general idea of what happens and where, let's take a look at the things that support and propel the color managed workflow forward— the digital darkroom components.

A while back I went out and did some shooting, came back, sat in my retro-'60s lounge chair (dubbed the "Grover Chair," for the Sesame Street character whose fur was the obvious influence of the person upholstering the chair, in bright orange, no less), and downloaded the files. I set to work sorting, correcting, and cranking out around 20 work prints on my Epson SPR2400 printer. I was at it for a while, but sitting in the comfort of my home, listening to the stereo, and chatting with my wife as she walked through the room—not like the sequestered, time-consuming process that was traditional darkroom print making. No chemicals, no setup, and no cleanup. I sat down in the comfort of my own home and made photographs. It really is a wonderful thing.

Later on, I found myself missing the feeling of going into a somewhat insulated

environment and concentrating on my printing, so I moved my digital darkroom into more of an office/workroom part of the house. Sometimes, however, I enjoy just sitting on the couch with my laptop and messing with images.

The Hardware

The two most important components of your system are the monitor—the display—and the printer. The display is what you depend on to show the colors in your images. Simply put, if it cannot produce a color, you're not going to see the color.

In a sound studio, speakers are very accurate and have a huge range of output. These are called studio monitors, and are meant to be the evaluative tool for tweaking and creating sound. If you are mixing music that has cellos, you need to hear the cellos. If you're working with speakers that cannot make that sound, you're not going to hear that sound. Simple enough. If you are making prints of a red rose, you need a display that can shoot all the shades of red.

Only a few years ago, the big CRT displays provided good color fidelity for what seems now to be a fairly low cost. CRT monitors, short for "cathode ray tube," were those big TV-type displays. The cathode ray tubes went out of production, making the monitors far more costly. Combine that with the hazardous waste they created (primarily mercury) and the

competition of a smaller, lighter new product (LCD displays) that looked cooler, and there was little left for manufacturers to do but remove them from the marketplace.

Digital specialists were up in arms about this because we felt that there was no way an LCD could reproduce color as accurately as the old CRTs. However, the same time CRTs went away, LCD performance improved significantly. Overall, they were better and cheaper than they had been. Make no mistake—there are still some pretty bad LCD displays out there, but there are also some very nice displays, service-able for photography, that don't cost eleven million dollars. Just for the record, I inherited an older, once "state of the art" CRT display, and it was still in good condition. I was really excited—I hadn't had the opportunity to use one of these for a long time, and I was looking

forward to going back to the old "standard." As soon as I powered it up, I shut it down and put it into the trash. Why? I had completely forgotten about the flicker in a CRT and the resulting headaches. It's funny how we only remember the good times.

Choosing a Display

One of the most important things about a "color accurate" display is the ability to adjust the display in a predicable way. Many LCD displays have adjustment controls directly on the display panel, but they do not really control what we need to adjust. The truth is, for some displays, I can't really tell you what they are adjusting. The secret of calibrating—at least trying to calibrate these displays—is to set the display to its default and not use the controls at all.

A good "color accurate" display gives you the ability to adjust the display, and we need to adjust three things: the black point, the white point,

and the color balance. When you adjust the black point, that adjusts what the display guys call "brightness," and the white point defines the display's "contrast." Why they use these terms, I do not know. If a display allows you to go in and actually adjust these two points, then we can get some good work done towards getting it calibrated. If not, it is more or less a shot in the dark.

Without really trying to give a product evaluation, I'm just going to throw some names out there to give you an idea of what to expect. Lacie and Eizo, for a long time now, have given us very accurate color displays. They start at around $1000, depending on the model, and give you the ability to adjust the black and white points, as well as go in to the red, green, and blue filtration and determine what needs to happen to bring it into specifications. The high end of those displays are quite a bit more expensive, and actually claim to be able to reproduce colors in the AdobeRGB space (your average display shoots something like sRGB).

Less expensive displays come with a wider range of performance, even within a manufacturer's product line. Some deals are great and some are really bad. Microtek had a great, inexpensive LCD for photo work at one point, but the next model down was completely unusable for anything needing even slightly accurate color. I have a Samsung display that drives me crazy; there exists another Samsung that is great. Across the board, the Apple displays are remarkably accurate, but also not very

adjustable. I do recommend them because of their accuracy, but it would be great if I could tweak them a bit to get them even tighter.

Really, as I say in other chapters here, the thing I need most is a predictable output. I heartily bash the "what you see is what you get" idea (see page 18 for the whole WYSIWYG rant). Solid color management comes far more easily if you're not fighting with the display. A good display is a joy to work with.

I'd also vote in favor of a larger display. I have worked on everything from a 12 inch (30.5 cm) laptop to a 30 inch (76.2 cm) Apple Cinema display, and it wasn't until I saw a photograph that was printing as an 11 x 14 inch print (27.9 x 35.6 cm), displayed in full, at print size, with my toolbars visible and useable, that I really understood why a large display makes for a more efficient workflow. At this point I would probably spend $1500 on a big, relatively correct display, rather than a small "color accurate" display. But that's me.

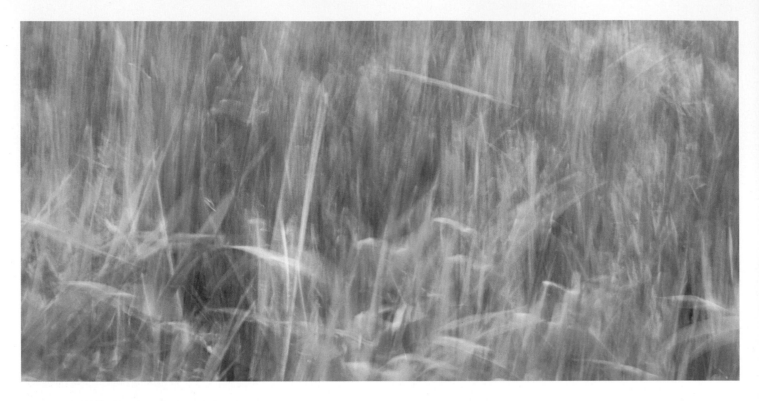

The Next Generation

The new Apple Macbook Pro came out in 2007 with an LED (light emitting diode) display. LCD displays have tiny fluorescent tubes on the top and bottom and use liquid crystal filtration to make the image on the display. When you apply a charge to the liquid crystal, it changes how and where the light shines through. The latest method to provide that backlight is with LEDs, which really are nothing more than very small light bulbs. NEC was the first company to produce these, and they have been well received as high performance, color correct displays. They still use the LCD filtration, just in different way to provide more efficient backlight with a better range.

Ambient Lighting and the Display

There's a question that always comes up when I talk about display calibration. That question is, "Should I turn the room lights off, or not?" The answer is a two-fold yes and no. The simple answer is, you should generally calibrate the display for your working conditions. But the between-the-lines message here is that you should work in subdued light. So, yes, you should be in dim—or subdued—lighting when you run a calibration, but this lighting style should also be your working environment. There are a few reasons for this.

First, think about the human eye. I talk a lot about the idea of giving the eyes a rest often, because the human eye has the ability to adapt

to a specific perception of color and tones—a principle called "color adaptation." This describes the tendency for our eyes to bring what we see into a comfortable context. If you are in a bright area, your eyes will adapt and restrict the light. Interestingly, your eyes will also try to neutralize colors. When we are under cool-white fluorescent light, we generally aren't aware of the fact that the light is, for example, very green. Our eyes and brains want to see the colors "correctly," that is, visualize colors as if they were neutral, white, and black.

If you stare at a screen long enough, you are not going to see a color for what it really is. Only by looking away and giving yourself a break, can you see the color accurately. I had a student once who would get up and stand back from the display to see the image from a different perspective. I tried it and it works great—so great that now my ideal workroom is an old drawing table almost at standing height. I can stand

up easily, walk around, stretch my legs, and take a fresh look at the display.

Keep in mind what is opposite the display, and how that compares to the lighting that you are working in. If you have a window behind you as you sit at your workstation, there may be a

significant amount of glare—enough to make the display appear less than accurate. Be very aware of what is behind your display, too. My desk in Boston looks over a wonderful view of the famous Newbury Street, but compared to the room light, the view out the window is really quite bright. This is great for street watching, but not so great for adjusting photographs. My eyes are constantly trying to adapt between the display and what is shining behind the display.

Direct, harsh light on the display should be avoided. Here is a very dramatic image of a display with direct sun on it. My blacks are two completely different values and affect every tone in the image. It is essentially impossible to see a display properly with direct light falling on it (thus, the use of a hood or shade on higher-performance, color accurate displays).

My ideal work area has subdued, even lighting, with no direct lights on the screen itself. I like to work with a hood on the screen even when I have control over the light hitting the display, if for no other reason than it separates the display from the background and gives me a border around the screen.

Print Viewing Light

The single most overlooked element in color management is also one of the most important elements in the whole system: the lighting under which prints are viewed. Ideally, you need an area that has the same lighting as where the prints will finally be shown. A commercial photographic printer usually has a viewing booth where prints can be seen under a variety of lights—daylight, tungsten, halogen, cool whites (white fluorescent), and any other possible lighting scenario.

Here is a studio I put together a while back, as both a digital "lab," a small gallery, and a classroom. The walls were painted a nice neutral gray, if a little on the warm side, and the rugs and other accessories were also a muted color. The prints on the wall were lit with direct halogen spots, to give the room some light, but kept glare off the workstation screens. It was a great place to work—very easy on the eyes—and allowed me to see the display accurately.

Small viewing booths are fairly pricey, but create a standard for evaluating the print. My commercial studio had standard office lighting (cool whites), and standard halogen track lighting in the gallery area. I also had a worktable with a "task light" that could switch between tungsten and fluorescent. It worked well.

It is tempting to set up your equipment, even with sun shining brightly in the room, but it is not a place that you would want to make critical color adjustments. The reverse is also true—for all the people who like the "cave" approach to workstation lighting, I don't think it's any better than working in a bright, sunny room. There is simply too much contrast between the bright screen and the dark room to allow your eyes to perceive the on-screen values correctly.

Most of the commercial prints I made I evaluated under the cool whites on the assumption that the prints were going to an office, where

the guy signing the check was probably viewing them under office lights—cool whites. Anything that might hang on a gallery wall went under the gallery lights—the halogen spots. I made the prints under my standard, near white lighting, and then took a look at them in the gallery to see if they would hold up.

This is why it is so important to have consistent color results from a display. The theory is, if your display is good, and calibrated, you should be able to hang the print in a viewing booth right next to the display, and they will look very close in color and density. I've done it with some really nice, dialed-in equipment, and it's a wonderful thing. (But I still hold to my guns about the WYSIWYG myth.) Evaluate prints under the lighting conditions you are printing them for.

Printers

"Never underestimate the Great Yellow Father in Rochester."

This was proclaimed to me back in the film days—accompanied by a wagging finger and windblown hair akimbo—by my good friend Nick Wheeler while we discussed film types during a long wait for a dawn photograph of a building. I was complaining about a new film I tried. While boasting a lovely saturation and vivid rendering of colors, this film had an absolutely evil pink cast in what was supposed to be a gray tone. This was particularly problematic when my client demanded a reshoot because of

the pink—rather than gray—backgrounds on a catalog product shoot.

Nick was admonishing me to stick with what I knew to work, and stick with a manufacturer that had the highest quality control standards and performance borne out by time. That made a big impression on me. I've always been reluctant to try new films and processes when I already had something that I was familiar with and worked well. No doubt, if you've read any of my other work you've heard that theme repeated. Simplify the process, understand what it does, and take the guesswork out of your end result. This experience underscored the wisdom of that approach, and also further underscored, for me, the foolishness of all the photo magazines and their constant pushing of the latest new film. Amateurs could have it. I was sticking to my Tri-X and my Ektachrome.

Well, times change, and the Great Yellow Father is not what it once was. As far as printers go, I'd say we're working with the "Great Mother Printer at Epson," to use Bill Atkinson's terms. I have literally tried almost all of them, and I keep returning to the printers that consistently set the bar in performance, reliability, gamut, and long print life. Other manufacturers have introduced pretty impressive products into the market—Canon and Hewlitt-Packard, notably—but Epson remains my printer of choice, and I swear I'm not getting a dime from them to say that. Epson has, since the very first Epson Stylus Photo that changed my life, been at the forefront of ink jet printing, and enjoys the widest support in the far reaches of the industry (like available paper types, profile and RIP support, and a host of other issues).

Choosing a Printer

I'll start with stuff you don't really need to worry about.

Resolution

The funny thing about printer resolution is it has nothing to do with "digital image" resolution. (Check out my "dpi" rant on page 15.) Epson Photo printers claim a 2880 dpi, and beyond, resolution. Much like the confusion surrounding "megapixel," the "dpi" specification is a really handy number that marketing people use to sell printers. The theory, of course, is that higher resolution is better. Here's what's wrong with that.

Image resolution is determined by the number of pixels in every inch, or pixels-per-inch (ppi). The highest resolution any of these printers can really use is around 180 ppi, and I've been printing on these things for, well, ten years now. So, as far as the image is concerned, the resolution beyond that is meaningless. That leaves us with the question of how fine the droplets have to be for the print to appear continuous.

When the 2880 "dpi" printers first came out, my favorite Epson tech rep basically said they never print at 2880 dpi in a demonstration because it uses up too much ink, takes too much time, and you could not tell the difference. I took that with a grain of salt, since these guys are basically making a sales pitch, and not fine prints. Then, on meeting with Bill Atkinson in his studio and asking him about the 2880 dpi setting, with a gleam in his eye he quipped, "It definitely lays down a ton of ink, and that is all I'm going to say." I took that as a challenge, and made some test prints. I measured out the blacks, and the result was a really astounding difference between the prints. By my measurements, the prints printed at 2880 dpi were about 20% darker black than those printed at 1440 dpi.

But here's the punchline: no one, not one single person, could actually see the difference. I had these prints up, side-by-side for months. Photographers, professional and amateur, and printmakers came through and examined them, scrutinized them thoroughly, and, even after being told what the difference was, could not perceive any distinguishable difference.

Nor have I been able to see any difference in tonal transitions or color gamut. Almost every ink jet printer out there is able to print at 2880 dpi or higher, even my son's Epson R220. Go with any of the mainstream "photo" printers, but remember that anything over 1440 dpi is just marketing hype.

Cost of Ink

Please, don't even consider this. When you look at what these printers can do, and how cheap they are—even considering the cost of inks and papers—it is a very, very small fraction of what a traditional darkroom cost to set up and support. I was recently talking to a class of undergraduates about what a custom, traditional darkroom print would have cost—back in the day of actual darkrooms—as they were complaining about paying $30 to the school for a 30 x 40 inch print (76.2 x 101.6 cm). They were flabbergasted. The point I'm trying to drive home here is that the cost per print is not something I consider in choosing a printer.

The other thing that drives me nuts is the question about installing "bulk ink" systems. There are several problems with that. First, it voids the warranty on your printer. Second, the very thing that makes a printer like the Epson SPR2400 perform as well as it does is the ink, and now you're telling me you want to use another, inferior ink that is around 10 or 20% cheaper. Talk about penny wise and pound foolish. Third, it is a kludgey mess of pieced together hardware-store parts. (A "kludge" is a great machinist term for something that is hack, shoddy, or silly.) They clog, break, and are just, well, kludgey. Finally, there are printers out there with larger ink capacities that save you considerable money per liter of ink. The Epson

SPR4800 for example, allows you to run 220ml inks, giving you the absolute best price of ink per liter, and the original, Epson, Ultrachrome inks. And no kludge.

Important Considerations

Support

Technical support from the printer company is very important. A good tech support department will help you navigate the huge range of options available with digital printing: paper choices that are truly compatible with the printer, color profiles for these papers and the printer, driver support, troubleshooting, etc.

We are not cobbling this stuff together anymore, and my best advice is to go with a good, mainstream printer that has good, mainstream support.

Paper Handling

That brings us to paper handling. There are a couple of considerations here in setting up your "darkroom," and it not only deals with the simple width of the paper you want to use, but also the type of feed you can take advantage of. Some of the bigger printers are primarily set up for roll-feed paper. They can take sheets pretty easily, but not in any kind of volume—that is, you can't load them with a tray-feed. Roll paper is great, and easy, and the cost of the paper is cheaper per square foot, but it also has a few drawbacks, such as paper curl on smaller prints.

As you get into the medium-format printers, generally in the 17 inch (43.2 cm) wide format, you have a range of printers that are set up to work with very good paper trays, accommodating full-format sheets of paper. The roll feeds on these printers are still pretty robust, but they start getting a little sketchy with the ease of loading and changing papers on the roll. When you get into the smaller printers, like my Epson SPR2400—although you can set it up for roll paper—in my opinion it's just not worth the effort. The other consideration in the format issue is back to the ink—only when you get up to the medium format, 17 inch (43.2 cm) printers do you get to significantly larger, more cost effective cartridges. These are designed for high-volume printing though, so keep in mind that if you're not running the printer a lot (meaning daily), you are going to have issues with inks and heads clogging and drying up. Believe me, if you think it's painful buying a $100 ink cartridge in the first place, you don't want to know how it feels to have to throw one out.

The bottom line: decide what you really want to do and pick the right tool for that job. My machinist buddy used to say, "You can make a small part on a big lathe, but you can't make

a big part on a small lathe," and I say the same thing about printers. If you want to make big prints, go with a big printer. If you're looking for commercial features—like volume in efficiency and RIP support—go with a "pro" printer. Don't, however, buy more printer than you need. If you're only making small prints, it's foolish to use a great big printer. Regardless of your workflow and final output, choose a printer that will give you adequate support for the long haul.

One more last bit to keep in mind. If you're interested in making huge prints, keep in mind the costs of storing and displaying those prints. I had access to a nice 44 inch (111.8 cm) format printer for years, and for the first few years I went on a huge-print tear. This is great, except now I have rolls and rolls of prints, and I can't afford to frame even one of them. The biggest print I ever made in the darkroom was 11 x 14 (27.9 x 35.6 cm). Since when did every photograph have to be 24 x 30 (61.0 x 76.2 cm)? Since never.

The Computer

To say that choosing digital equipment is a personal decision is a bit of an understatement in today's bit for byte environment. There is no shortage of issues that, when they arise, are guaranteed to start a spirited debate. It never fails to amaze me how people can attach their identity to a feeling of brand loyalty (especially in the photography industry). That is, of course, the goal of any good ad or marketing campaign, so it shouldn't really be a surprise, nor can I say I haven't occasionally succumbed to it myself.

Throughout my career as a commercial photographer, I held my equipment up as a crucial part of my photography. I felt that I needed to know and respond to that camera in order to accomplish a job. My dad always said one of the important differences between an amateur and a professional photographer is that the pro comes back with photographs every time. This reliability, to me, seemed to demand intimate rapport with the equipment.

After a few years back in the retail arena, I had the chance to have hands-on experience with virtually every major camera system. I soon learned that it really isn't about rapport—it's about flexibility. I can now pick up almost any current camera and, within a few minutes, use it comfortably at its highest capabilities. Professionalism is about understanding the system, not the individual device, and understanding how to implement methods and techniques that are applicable to any particular camera.

And so it is with computer systems.

Choosing a Computer

The single most important thing for working with a computer system is to use methods and techniques that are safe, reliable, powerful, and realistic. In a word: professional. I really don't think it matters whether Apple or Microsoft makes that system—it simply needs to be built for the task at hand and set up and handled correctly. There is much to consider in that process, but here are a few key issues.

Cost & Reliability

The old adage is, "You get what you pay for," and in the auto racing community it's said, "If you want to go fast, you have to pay the money." Of course, we all know this translates—in terms of electronic products—to quality control standards. Usually the biggest difference between a cheap drive and an expensive drive is that the cheaper drive has lower quality control standards. Lower quality control standards means manufacturers accept higher failure rates in their testing, so there is a higher chance that one of those drives will fail. In my cynical view, the reason a drive (or any other component) is more reliable is that, although it may have a better standard of materials and design, essentially the manufacturer must throw out more parts to make sure they deliver parts that work. This makes the parts they do deliver to the consumer more expensive.

Horsepower

An important consideration is horsepower. One of the best ways to get the most out of a system is to give it more RAM. (RAM, or "random access memory," is essentially working memory, kind of like your workspace. If you have a big space to work in, you can work on big stuff.) But RAM costs money. Processor speed allows you to work with files faster. Hard drive speed and capacity allow faster and more reliable access to your work. Storage, and redundant storage at that, ensures that you work in a safe way, and guards your images against catastrophic equipment failure. This all costs money, and in general, the better your tools are to do the job, the more expensive it will be, regardless of brand.

Dueling Devices: Mac and PC

The Microsoft/Apple decision does have a few points to consider based on your personal needs. One consideration—assuming you already have a system—is how much you have invested in existing software. If you're deep in PC compatible applications, then it doesn't make much sense to switch.

But seeing that this book is about color management, that is the issue I will emphasize here. As of Windows '98, we saw Microsoft attempt to devise a good color management policy—to be honest, Windows was simply re-doing Apple ColorSync. We've talked a bit about ColorSync so far, and it features prominently through the rest of the book, so the only thing I'll really say about the Windows version is that it seems more complex, and in my opinion, less reliable than ColorSync. I really thought that with Windows XP we were seeing a color

management engine that, although it was not simpler, started to act like it was working. All bets were off with the introduction of Windows Vista. Make no mistake, you can get it to work, for the most part—it just isn't easy. (If you want a real-world example, try to find a printer profile in Windows—any version. Then search online discussion groups for Windows color management if you have a free, rainy afternoon.)

Much of the reason for the difference in these two computer systems comes down to their target market. Windows is more widely used and has a huge client base with every possible need for the system. Apple is, and has always been, aimed specifically at the creative market, and thus, has to make fewer compromises for their audience. One interesting story from the history of Apple was in the development of fonts and how important that "beauty" was to the interface. This was at a time when Microsoft still ran DOS; for PC users, fonts and typeface were just not important. From these foundations

the two platforms were built, and today's products are a result of that history.

I've heard a lot about the cost of Apple products, and I'm just going to say this—having priced out building identical systems with identical components (brands and models of drives, memory, etc.), the costs have been identical. You get what you pay for. Also, consider the warranty. AppleCare gives you onsite service for three years. I don't know of anything else available that does that. When you have a system that weighs 40 lbs. that you have to deliver or ship to a service center for warranty repair, the AppleCare deal sounds pretty good.

Another consideration is file compatibility and support. Here is where it's most important to me: profiles. As long as my favorite paper and favorite printer have profile support on the system I'm using, I'm fine. You can be pretty sure that an Epson Pro series printer will have Mac profile support on the Crane Museo website. This is not necessarily true for other printers and other operating systems, and when you start combining the possibilities, you can see where this is going. If I have a Windows Vista system and a Canon photo printer, I could be on thin ice.

As with cameras, I've now run just about everything. My usual joke is, I don't prefer one system over another, I fight with them all equally. So make the choice in an informed way, realize you are not going to get anything for free, buy as much horsepower as you feel you need, (keeping in mind that even the most basic configuration now will take care of about 75% of photography requirements), and try to step away from your Windows t-shirt and your Apple baseball hat. Above all, stay in the mainstream, where the lifeboats live. It's not about the brand—it's about the job at hand.

As you read through the rest of the book, you will notice that none of the instructions refer to Windows. I've made that decision very consciously, and here is why. First, Windows color management, as I have said, is more or less a mirror of ColorSync, so at the system level, explaining Windows would be redundant. Second, as I said, the jury is still out as to whether Vista is really stepping up to the plate, and Windows seems to be trying to reinvent the wheel. Any discussion of Vista at this point would need almost a monthly update. Third, as I knew once being a Windows imaging user, you Windows folks get pretty good at translating books from Mac to PC. The main difference is the menu directions are slightly different, and if you are familiar with your operating system, you should have little difficulty following along.

PART 4:
UNDER THE HOOD: CONTROLLING COLOR

We have a pretty good idea of what happens to the colors as they travel along through our system. Now, let's take a look at what kind of control you have, and where you have it. Many of these points we'll come back to in more detail, but let's start with an overview.

10 THE SYSTEM OVERVIEW

What You Can Do, and Where, Along the Way

Capture

At image capture, we have the job of making sure the desired image tones are placed correctly on our curve. This means making a near-to-perfect exposure, and here we can use what I call the most powerful tool of digital imaging—the on-camera histogram.

We also can "tag" the RAW file with a few key settings that will determine how the file is going to be processed for the histogram. These settings—like tone controls, white balance, and sharpening—are most important for confirming the correct histogram display on the camera. If you are relying on the histogram to evaluate your exposure, it must be set to the options you prefer. Probably the most important setting here, in terms of color management, is white balance. This determines how the colors are processed from the RAW file.

HINT: The camera will make thumbnail-sized JPEGs of your images for the histogram display as well that are processed according to the camera settings you've chosen. They are imbedded in the RAW file metadata. They are the images you see in Adobe Bridge if you select the "Quick Thumbnail" option in the Preferences menu.

RAW Processing

As you download images and prepare to process them, you need to make some important color system and editing decisions. In terms of the color system, decide what working color space you want to process the file in. It's important to understand that, just because you can process colors out into a larger color space, does not necessarily mean you should. Because you are "rendering" the file (translating it from its native color space to the working color space), it is best to render it to a space that is appropriate for your purposes.

Outside of choosing a working color space, I make large scale editing decisions here. This is where I create the photograph out of the basic image data and begin the "constructive editing" process. The most interesting "color system"

decision is the choice of a "camera profile," (available with some camera software). We can apply one of the camera manufacturer's processing profiles to achieve a certain look. These preset profiles do this by adjusting a file's value data—such as contrast, color, and brightness.

You can even build your own camera profile. Some manufacturers offer a built-in profiling utility (Kodak's Pro software, to name one). You can also use a color management package (X-Rite, for example), to build your own profiles. Camera profiling is a source of great and spirited debate—you can be sure we'll explore this and more editing features in detail.

Photoshop

Once we have processed the file, we are moving into the application—specifically, Photoshop. Here we can control almost every level of the system, as well as fine-tune almost every level of editing. Let's go down the list (don't worry, we'll hit this again in much more depth).

DISPLAY PROFILE: The display profile is what the computer system uses to make sure Photoshop is displaying the colors correctly, although it is technically not inside of Photoshop. It is essential to calibrate your display to this profile. I strongly suggest investing in a good, color accurate display, and calibrating it with a calibration device rather than the built-in software that might come with your computer, regardless of whether it is a PC or Mac platform. A hardware calibrator is like a tuning fork: it gives you a precise measure and correction of the colors Photoshop is displaying. The quality of that calibration depends on the quality of the calibrator and the monitor's ability to display the colors you need. (It is best that this calibration is done to meet industry standard, not what "looks right" to our eyes.)

WORKING COLOR SPACE: Under Edit>Color Settings we can set the application's color management policies. As photographers, we

are primarily concerned with choosing an RGB working space (I'd suggest starting with AdobeRGB 1998), telling Photoshop how to handle mismatches (that is, if the profiles that are coming in with a file are not the same as our preferences), and defining how we want the conversions done.

COLOR "MODE": Under the Image>Mode selection, you can change the color mode—or color model—you're working with. Here is where you change the actual colors and tones in an image to either have access to different editing "handles,"—as with changing to LAB or grayscale—or to remap the colors to a specific purpose, like taking a full color image and mapping it down to "web" colors. (Making a GIF graphic, for example, for a website.) When we talk about editing in LAB, you can be sure we'll hit this one hard.

My students hear this all the time: The single most powerful tool for current digital imaging is the histogram, whether in the camera or in the Levels dialog of Photoshop.

A histogram is a graph of the tonal values of the pixels in an image—it plots out the actual tonal values of the photograph the moment I take the picture. The histogram in Photoshop's Levels dialog displays exactly where tones fall, and with a little experience it becomes easy to deduce how they will print. The trick is understanding the histogram and learning to use it correctly.

Look at this image and the resulting histogram. The tones in the image range from medium-dark gray to medium-light gray; the histogram shows that very clearly. None of my tones map out to the edges of the graph. Nothing hits the far left (pure black), and nothing hits the far right (pure white). As with any other scene, my camera meter tries to average everything out to neutral gray—something my Dad used to call trying to "see everything as gray." It measures the entire scene and places the range of values from light to dark smack in the middle, giving me this histogram that sits in the center of the graph. I can photograph a black dog and my camera will try to make her gray. A snowy field—gray.

This is a great example. Look at the thin lines to the left and right of the main black area of the graph. They are almost perfectly centered between the pure black and pure white extremes.

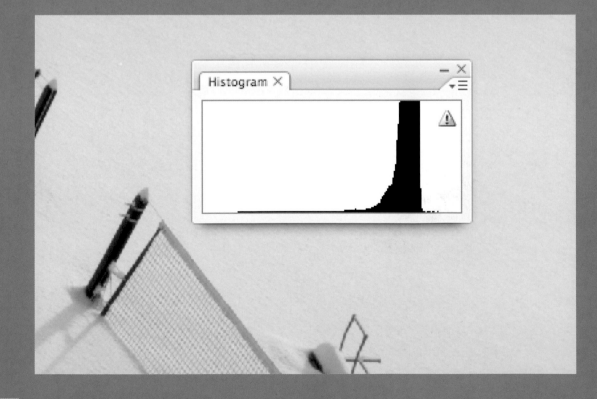

If you let it, this image will print just as you see it—gray. You can adjust it in Photoshop, but the better thing to do is to capture it where you want it in the first place, mapping the whites to the white values and the grays to the gray values. That is our question—how do you tell the camera where you want to put these tones?

The answer is with the Exposure Value (EV+/-) control. Assume you want to shoot with automatic exposure, either in Shutter Priority or Aperture Priority. The EV control gives you the power to tell the camera to over- or under-expose the image. Going to the "+" side makes my snowy scene brighter; it pushes the tones up on the histogram and brings the lightest gray values closer to white. A little practice will show you how much to boost it, but the histogram on the camera will show you precisely what the effect of the boost will be.

Here's what it looks like when I boost the exposure by +1. Immediately, you can see the snow reads white, but more importantly I can see on my histogram exactly how white that is. It is just a small skip away from the pure white of the far right of my graph, indicating that it still has tones. This is good; it means the file is not "blown out," or losing digital information in the highlights. (Hint: Use the Highlight Alert function on your camera to indicate overexposed highlights.)

Envision your final image, use the EV+/- control, watch the histogram to get the most information from the capture, and ultimately create the highest quality photograph.

profile that you select), and flag colors that are outside the range of colors you can print on a given paper, with a given printer. These choices do not alter colors in the image file; they simply allow you to play with them safely.

PRINT: Here is where you can take the file from your working color space and remap the colors to send them to the printer. This is the final stage of color management outside of the printer drivers. In most cases, we're going to use "application color management,"—this means Photoshop controls the printer/paper profile, not the printer. Here we can have a lot of fun. It is pretty easy build your own printer profiles now. Custom profiles for many standard papers are available for download on the Internet, and usually for free. You can even use "bouquets" of profiles (as per Bill Atkinson), to select the color rendering that best suits your taste. We'll certainly explore this later, so don't fret—this is fun stuff!

EDITING COLOR: Of course—this is what Photoshop does best, after all. We'll discuss editing colors globally—that is, over the entire range of the image; and editing spot color—selecting specific colors and making precise adjustments to them. Lots more to come on that.

ASSIGNING AND CONVERTING TO A PROFILE: You can access these options in the Image navigation menu. We'll talk a little bit about them later, but, for the most part, these profile decisions are made when the file is first brought in using the color settings we've discussed.

PROOF SETUP AND GAMUT WARNING: These are found in the View navigation menu, and allow you to set up a way to "soft proof" (view the image on the monitor as it will print using the

The Printer Driver or RIP

Most often we're just turning the printer driver color management off, with the exception of Epson Advanced Black and White. Epson—with the Ultrachrome Ink printers—has given us

a truly superb control for printing black-and-white images. This is found in the printer driver, not in Photoshop. In this case, we're using the "Let Printer Manage Colors" choice in the Print dialog.

A RIP can also take over the color management duties from Photoshop by translating the file from the working color space for the printer. A RIP (or Raster Image Processor) is a device that, using Postscript, translates digital information into data that a printer can understand. In most cases it is an open structure, which means that most RIPs allow me to build my own printer profiles and apply them within their color management. We'll talk about that a bit, but frankly, unless things change dramatically, most RIPs are now going back to their roots and simply handling postscript processing and

highly evolved press proofing. They are great and wonderful, but are not something I think we, as photographers, need to spend much time on. In the recent past, they were the only way to get good color out of our printers, but this is no longer the case.

Print Viewing Light

As we discussed on page 74, this is one of the most critical steps along the way, and honestly one of the most overlooked. The intensity and color of your viewing light makes the most profound difference in how you see your print. My best story about this comes from a color management training session attended by professionals from all over the country. We were

making a print that was supposed to match the screen. It didn't. The engineer flagged down the president of the company, and kind of humbly asked him what he had overlooked. (Color management tends to humble everyone at one time or another.) The president took the print, moved it out from under the cool-white fluorescent lighting and put it in the daylight, color controlled viewing booth. It matched the display perfectly. He never said a word.

Any good color lab—back in the day—had a light booth with the ability to view the print under any possible light source. Even in my black-and-white darkroom, I had track lights that simulated gallery lighting. My print viewing lights for color, when I had a lab print, were cool-white fluorescents. Most of my work then was going to corporate clients. I can't overstress the importance of the viewing light, and we will come back to it.

So let's tear into each step. Where our controls are part of the system, we have to make sure we have them set right. Where we can make decisions, let's be aware of them, and make them in an informed way.

In the discussion about profiling and calibration, I think the term "linearization" gets a little lost. Linearization is sometime described as calibration, or standardization. I've even quoted Bill Atkinson as saying, "The Stylus 9800 printers are extremely linear; they are the closest thing yet to the great mother printer in Japan." The implication here is that it is more of a standardization process. It is that in part, but it is also an issue of making a smooth "response ramp" for a device.

Let's start with a pixel on a sensor. I've described it as a little light meter that generates voltage to correspond to the amount of light that shines on it. Actually, that's not quite accurate. Pixels are more like little valves—they are given some current and, when exposed to a light source, actually let more or less of that current "through," depending on how much light they sense. The end result is the same—a voltage reading coming out that corresponds to the light. I wanted to clear that up so Bruce Radl and Joe Holmes could sleep at night.

The problem is we don't get a smooth, across the board response to light from each little light meter. Some little pixels may be very good at seeing low levels of light, and not so good at the medium levels. Others may totally blow out the higher responses. The process of linearization is simply to take the response out of a device and smooth it out—make it linear. We want it to read zero at zero. If we load it with a little light, we want it to go up a little. If we feed it twice as much light, we want it to respond with a number that is double.

Here is a printer linearization curve, from the ColorBurst RIP. (This is what Bill Atkinson was talking about above.) It is a map of each ink color, and how it "tracks" from light to dark, with the appropriate corrections. Look at the magenta graph. Magenta plays pretty well up to around 50%, where the RIP must dramatically boost the amount of ink to get it to be linear. I would guess from this, that if you printed out a series of neutral gray patches without linearization then you'd see—at middle gray—a dramatic drift to a green cast in the gray values. The linearization curve fixes this by feeding in more magenta ink.

Every printer is an individual device, and ideally needs individual linearization, but Bill's comment was simply saying that the printers were, first, pretty standardized (they are all pretty close to performing identically) and at that standard point, pretty linear.

Linearization is the process of smoothing out the bumps in any device. And by the way, every single pixel in the sensor is going to have a different response curve. We have to linearize the readings of every single one—thousands of pixels on the sensor—to get a balanced and predictable image.

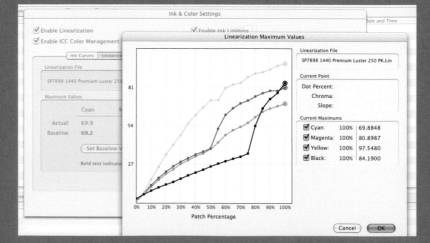

Profiling any device assumes that the device is consistent. That is, you're going to start with the same environment for making the colors, so then we can see what the device makes and fix it. A scanner starts up, looks at itself, makes some little adjustments, and puts itself into a "baseline" status—that is, it adjusts itself to the brightness and color of the light it uses to scan with. And there is the problem with cameras.

Every time you move your camera, it changes the light source, the color, and the characteristics. A scanner has a constant light source. There are known scanned materials (a selection of film types, for example) to define standards.

Cameras, however, have the great wide world to manage. Even in a studio environment, with a fairly consistent light source, profiling can get complicated. In most cases, camera profiling for a studio works pretty well. But as soon as you change something—anything—your profile becomes suspect. Even just dialing down a light source may slightly change the color, necessitating a new profile.

Color scientists would love for this to work, but the cold truth is, it needs some help. Interestingly, profiling software has evolved to a state where it is fairly easy to build a profile and then fine-tune it by eye—essentially tweaking it to suit your needs.

There are two places you can plug in a camera profile. One is in the RAW processing stage, with certain RAW processing software; the other is when you bring the processed file into Photoshop (much like applying a scanner profile to a scanned file). I want to start by going through the process of building the profile using X-Rite's i1 Match, and then we can look at some specifics of where and how to use the profile.

Building the Profile

The first thing you need to do is photograph a specific standardized target, and what i1 Match needs is the ColorChecker SG chart, shown here.

This is a much larger array of color patches than the familiar 24-patch ColorChecker, and in fact, the standard ColorChecker sits right inside this expanded chart.

Shoot the chart, ensuring it is lit evenly and exposed correctly. The chart really needs to be clean and fairly new, because colors fade and marks or dirt on the patches will change the color. If there is a glare or a shadow, it will create an error when you try to build the profile. Process the file as a TIFF. (We'll talk about the processing settings a little later, but keep in mind that they are critical.)

Next, start i1 Match. You get this screen asking you what lights you used for the target. We used strobe, so I set it to D50, or 5000K. (They even show you a picture, emphasizing the need to light the target properly. I love these guys.)

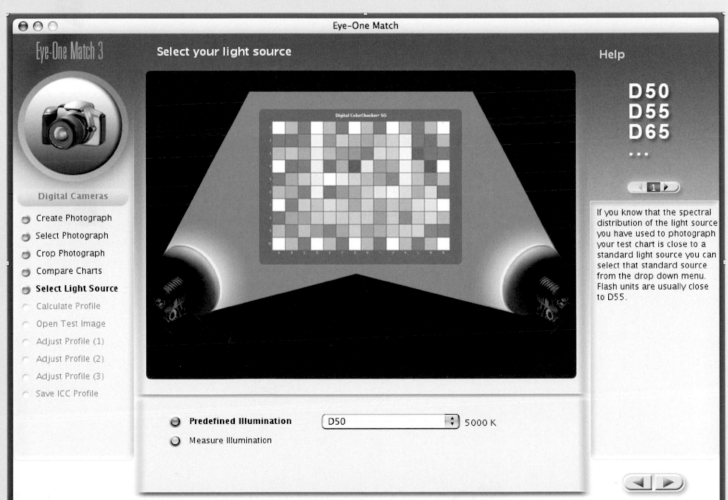

Here are the screens where you are asked to load the target file you've created and crop it so the software knows where to look for the color patches. It then builds the basic profile.

This screen allows you to precisely crop to the
target so the software knows exactly where to
look for each color patch.

The next screens allow you to go in and make some adjustments to the profile, in darkness and lightness, and saturation, then apply them to the profile. You first load an image, and then make adjustments "to taste." The profile is then rebuilt, or amended, to take these adjustments into account.

Eye-One Match 3

Save ICC profile and summary screen

Help

Digital Cameras

- Create Photograph
- Select Photograph
- Crop Photograph
- Compare Charts
- Select Light Source
- Calculate Profile
- Open Test Image
- Adjust Profile (1)
- Adjust Profile (2)
- Adjust Profile (3)
- **Save ICC Profile**

The digital camera profile has been calculated successfully. You can save your profile now.

All modifications are shown in the summary screen.

Summary:

0	Exposure Compensation
-4%	Contrast Adjustment
0%	High saturated colors
0%	Pastel colors
-20	Fine Tune Shadows
Off	More Details in High Key images

e10testchart.icc Save As...

Repeat with different image

You are then asked to name and save the profile, which is automatically loaded into the ColorSync folder.

ColorMunki is a fairly new product by XRite aimed squarely at photographers and designers as an alternative to more "color scientist" tools. Not surprisingly, it feels very much like the i1 Match we've seen, but a little more evolved and, for the most part, easier to use. It is not really "dumbed down;" in fact, like most good software, it offers explanations and illustrations so that the attentive user will learn a lot from diving in a bit deeper.

The package has a nice, integrated device that—unlike cheaper calibrators—has a built-in calibration patch. Pricier calibration systems read a standardized white patch to "baseline" the device, but with ColorMunki the white patch is inside the calibration device, and before you do anything it will ask you to read that patch. Beyond that, the process is much the same as all the others.

The thing that is slightly different with Munki is in the printer profiling process. As we've seen, you usually print out a whole bunch of patches and then read all of them. The software compares the actual readings with what it should be, and builds a corrections table. The Munki— in an attempt to speed up the process—gives you a very small assortment of patches, on only one page. They are big, the chances of misreading them are small, and it goes quickly. Here's what that looks like.

Print 1st Test Chart

To profile your printer, ColorMunki requires you to print and measure two color test charts. 1st Test Chart provides information about all color regions that your printer is capable of producing.

Print...

☐ I have already printed my target.

After you're done reading that, the software analyzes those readings and decides where it needs to do the most correction. It generates a second target, based on those decisions, and tells you to print it out and read it. Here's what my second set looked like. This second set of patches is different every time, and fine-tunes the profile in the most critical areas.

This is a pretty unique way to approach printer profiling and I'm almost certain it is the same system used on the HP printers—like the z3100—with on-board profile building. It does make the process fast and easy, and its effectiveness depends greatly on the printer you're using. As far as its performance and the quality of the profiles, well, I have to say there is no substitute for time-consuming, expensive systems for building great profiles.

Beyond being a great start in color managing your system, the Munki is a great tool to learn about the bigger color picture.

Measure 2nd Test Chart

Measure the row indicated by the yellow marquee. If the measurement succeeds, the marquee will advance to the next row. If a measurement error occurs, the marquee will flash to red while the error is cleared. Once the marquee has returned to yellow, you may remeasure the row.

1 2 3 4 5

Click here for video instructions

Applying the Profile

When Photoshop starts, it scans the ColorSync folder and loads all the profiles it sees.

Using this profile is a simple matter of bringing the image into Photoshop, assigning the input profile, and converting the image to your working color space. Here's where you do that:

Edit>Assign Profile. The profile shown here—Camera_11-29-07_1—is the one we just built, so I select that.

Select Edit>Convert to Profile, and convert it into AdobeRGB 1998.

Assign Profile

Assign Profile:
- ◯ Don't Color Manage This Document
- ◯ Working RGB: Adobe RGB (1998)
- ⦿ Profile: Adobe RGB (1998)

OK
Cancel
☑ Preview

Aptus 75 Product 5
Aptus 75 Product HS 4
Aptus 75 Product HS 5
ARRIFLEX D–20 Daylight Log (by Adobe)
ARRIFLEX D–20 Tungsten Log (by Adobe)
BestRGB
C–Most HS Portrait
C–Most HS Product
C–Most HS–W Portrait
C–Most LS Portrait
C–Most LS Product
C–Most LS–W Portrait
C–Most NS Portrait
C–Most NS Product
C–Most NS–W Portrait
Camera_11–29–07_1
Canon EOS–10D flash
Canon EOS–10D generic

Assign Pr
◯ Don't C
◯ Working
⦿ Profile:

Preset Manager...

Color Settings... ⇧⌘K
Assign Profile...
Convert to Profile...

Keyboard Shortcuts... ⌥⇧⌘K
Menus... ⌥⇧⌘M

Convert to Profile

Source Space
Profile: Camera_11–29–07_1

Destination Space
Profile: ✓ Working RGB – Adobe RGB (1998)
 Working CMYK – U.S. Web Coated (SWOP) v2
 Working Gray – Dot Gain 20%

Conver
Engine: Lab Color

OK
Cancel
☑ Preview

Applying a Profile in RAW Processing

Adobe Camera RAW does not allow you to apply an input profile, because it does not use them. (More about that on page 223.) Many RAW processors do; the venerable old Kodak Capture Studio, from the days of Kodaks DCS

ProBack, integrated some of its color management software into the processor. Here's what I'm talking about.

This is the main screen, and when you go to Tools, select the Create Profile option. Load an image of the ColorChecker chart and go through the same steps we saw above (select the target, etc). What we are not allowed to do here is to fine-tune the target.

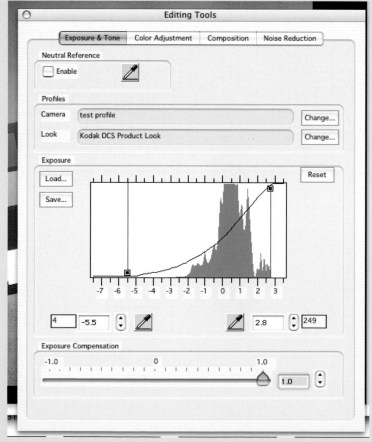

The main capture adjustment screen, shown here, is where we apply the profile before processing the RAW file. I've named this "test profile."

This is completely integrated into the Kodak software, so we are not dealing with questions about the target file being processed and altered in the RAW development. The Kodak software builds and applies the profile directly to the RAW file. If you're not working with such an integrated system, you must be able to turn the processing settings off, so that you're not "double-spinning" a file (double-spinning is like a "double negative"—you negate one correction with another), and making a junk profile. Here's the process in an independent processor, curiously called RAW Developer. (This is a great program that we will explore later for RAW editing in LAB.)

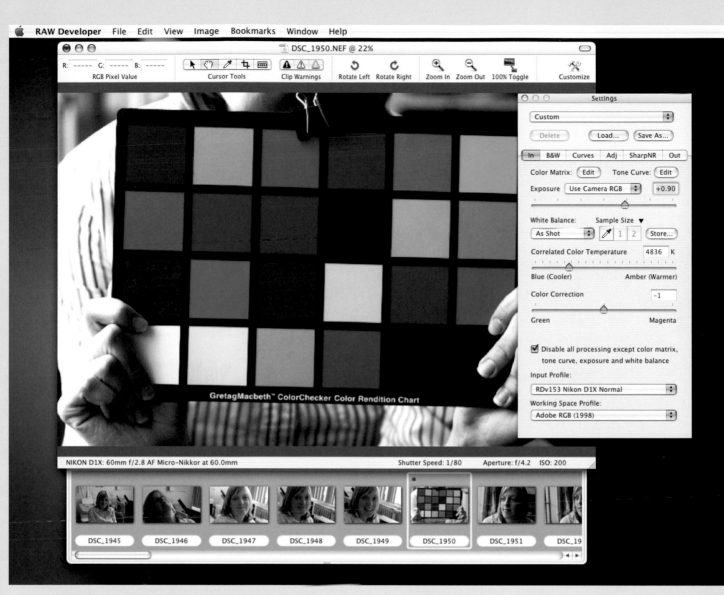

Here's the main window and where you tell it to process it "straight," with no adjustments. This is also where you will plug in your new profile.

Take this RAW file, process it to a TIFF with these settings, go back to X-Rite's i1 Match, and build a camera profile as we did above. It loads into the ColorSync folder, the RAW processor sees it, and allows you to use it. Apply it to the files you want to apply it to; it makes the corrections in RAW and bumps them out to Photoshop in AdobeRGB.

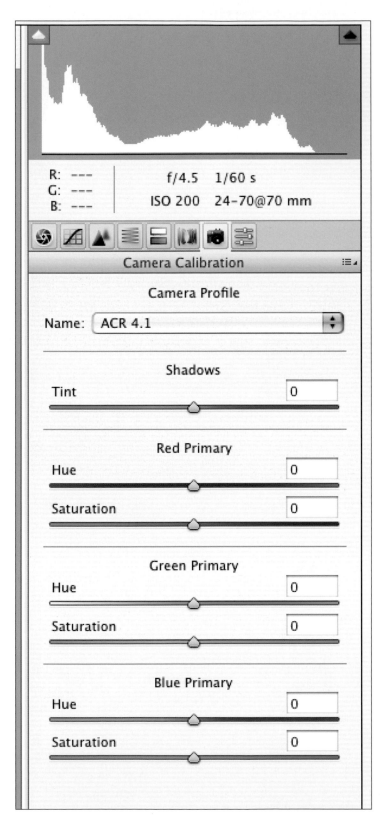

Calibrating Adobe Camera RAW

Adobe Camera RAW also uses a profile to map the color response of particular cameras, but Adobe does not allow completely open access to that profile. Instead of specific profiles for certain cameras and conditions, Adobe builds a fairly generic profile into the RAW plugin. When you open a particular file, Camera RAW decides which profile is best one for that camera. Generally, in the "Calibration" tab, you only get one choice, and it references the version of Camera RAW that the camera requires.

Although you cannot build and load your own profiles in a practical way anyway, Adobe does give you some pretty exact controls over how you can render your camera files— you can make some basic corrections to the image. For example, I like to take a little red saturation out of my E10 files, and then move the red channel over to the warmer hue to remove a bit of the magenta.

As Bruce Fraser describes in *Real World Camera RAW CS2*, you can go to the extreme of measuring each patch on your

Here we're showing a profile for a Canon 1D MIII file, which requires the Camera RAW 4.1 camera profile. My Olympus E10, for example, uses ACR 2.4.

target, zeroing out the Camera RAW settings. Then, one by one, you can try to get the chart to read correctly, building your own correction based on the very specific target values of the ColorChecker. Bruce also says that although you can do this, it could drive you crazy.

Once you have the files looking good, regardless of the process you use, you can then save these settings and apply them anytime you need them, or even set them as your default. Here you can

see my settings for the E10, with my red channel adjustments. I've selected the "Settings" pull-down, and I'm going to save these settings. I can use them at any time by selecting them either in the settings dropdown tab or by using the "Load" button.

By the way, these adjustments are really not based on shooting the chart, they are based on repeatedly making the same corrections to all the files I shoot with this camera when

processing the files. I shoot, I adjust, and then I fine tune. Regardless of my subject, I find I start making the same basic adjustments for each file. I've come to the conclusion that this is how I prefer Camera RAW to process the files from this camera, and it's based on having a calibrated, profiled display, a solid printing "path," and the consistent need to adjust the files like this.

Finally, if I want Camera RAW to use these settings every time (if this is the only camera I use, for example), and I want Adobe Bridge to display the images using these settings, I can do that by making this my default camera profile. Go to the bottom of the Settings window and select "Save New Camera RAW Defaults." To go back to the Adobe defaults, just select "Reset Camera RAW Defaults," and you're back to the factory settings.

Camera Profiling, Calibration, and Conclusions

In Iridient's Raw Developer, under the Help menu you'll find a nicely put, succinct explanation of how to make camera profiles and a bit about the process and its uses in general.

Interestingly, they call it "Camera Calibration," not profiling, which I applaud. Almost every discussion you read about camera profiling starts with a disclaimer about how it might be good and it might not.

In most cases where you have a fair amount of control—such as a studio product shoot with consistent lighting and a "closed loop" workflow—my experience is that profiling can work really well. With camera software, where you can easily build and use a profile, the process of updating and integrating a profile can be done virtually every time you make a change to the set. The further you move from that level of control and consistency, the more dramatically the results fall away from being useful. The precision of a camera profile will lock in my colors in a consistent environment. That same precision will go horribly wrong in an inconsistent environment.

Aside from the basic fact that I like working with Adobe Camera RAW—which does not allow me to use a camera profile—I think the

strategy of building a general profile is much better than trying to get into specific profiling. First, I'm trying to figure out what my camera does, in a general way. I know a Nikon D1X consistently makes skin tones too magenta, regardless of the lighting. I can fix that aberration across the board by making specific camera settings for the D1X and saving them as the default. I may have to go in and specifically tweak how the camera maps color during the color correction, depending on the circumstances, but for the most part Camera RAW works really well, and the only thing I have to do is "click" neutral balance, preferably on the ColorChecker.

Here is a good example of how I think this can really work well. I had a color management client who produced some major catalogs. They used a group of freelance photographers, and those photographers used cameras ranging

from a Nikon D200 to Leaf, Sinar, and PhaseOne digital backs. Needless to say, each photographer's files looked different—different color mapping, saturation, and even different standards of black point and white point processing. The catalog producer spent over 600 hours in Photoshop correcting files so they would look good on press. Needless to say, they wanted to establish some standards.

The typical approach to this would be profiling each camera, and that would have been a great solution if we knew that the photographers would use exactly the same lights, sets, and cameras, and nothing changed over time. However, that is not realistic. What we did instead was to make a more general set of recommendations based on some test shots—that is, we looked at the RAW files and processed them in their native software so that all of them looked fairly similar. This meant selecting the input profiles, the contrast curves, and the sharpening settings to make everything similar. We then made, for each program, a "Settings" file that every photographer could use in their processing.

It worked beautifully. This brought all the different files from all the different cameras into a similar state, and assured that the "look" of the images would be similar. It gave the color correction folks a common starting point.

Every digital camera, and every RAW processor, has a different "look," based on what the manufacturer thinks it should be and what the customer likes best. We simply made the same decisions, from camera to camera, about how we wanted each camera's look to be.

Raw Developer is a RAW processing program by Iridient Digital (www.iridientdigital.com), and it is very intriguing software. It boasts a nice clean workflow and gives good results, but they offer some pretty sophisticated features that are very much in tune with the more elegant ways of working in Photoshop. (You can try a free demo of the program that allows you unlimited trial time, but imports a watermark on processed files.)

The first thing that you get is access to the camera input profile, and the ability to make your own, use their preprogrammed profile, or use variations of profiles to fine-tune processing to your camera. Iridient offers input profiles for very specific camera models on its website:

www.iridientdigital.com/rawdeveloper/settings/, and this screenshot shows where you can plug in those profiles. The downloadable files have an ICC profile file for the camera, and also a "Setting" for the camera—this feature combines a standard ICC profile method of work with the Photoshop "profile by setting" method. With a little hard work, I think this could be a very versatile and precise way

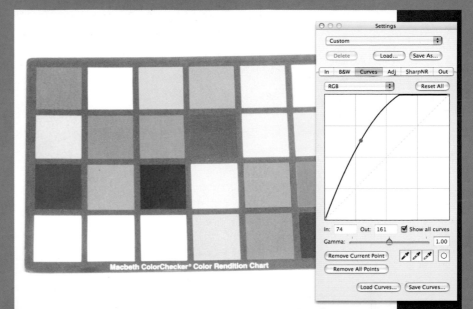

to process your files. It gives you the basic camera profile starting point that Adobe gives you, but adds options for choosing and modifying that profile.

The other cool thing about this software is your ability to edit, in RAW, with LAB "handles." Go to the Curves tab and to your standard RGB master curve. Here is an example of the RGB curve with a huge move to increase luminance. You can see pretty clearly that this introduces an objectionable color shift.

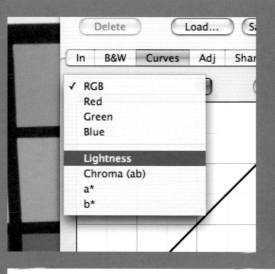

Here, I've selected the Lightness channel of LAB. This will allow me to make a similar move, but only affecting the lightness (luminance) of the file. The result is an image that is lighter, but does not show the same color shift we got from trying to grab the RGB master channel.

If you're into working with LAB in Photoshop, this is a major deal. You can make moves in the RAW process that are in the same "language" as the moves you're making later in your color edits in Photoshop. My hope is that—if these features in Raw Developer are well-received—we'll see similar features in other packages, particularly Photoshop.

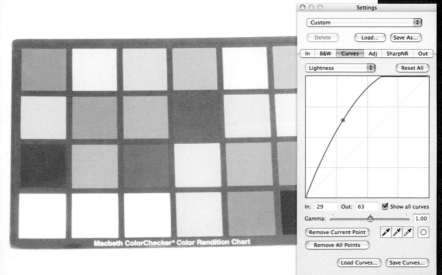

Display Profiles

First, it is vital that you understand we are building a display profile, which is going to sit in the main Library (Hard drive>Library>Color Sync>Profiles) and the system will look for it as the default profile to use when it starts up. You can change that by going into System Preferences>Displays>Color. There you will see a list of display profiles, and you can select the one you want to use.

There is no reason to do this manually, other than to see a comparison of the old profile and the new one you just built. That is helpful to see if the monitor is drifting or changing, or if the old or new profile is corrupted.

The display should be warmed up and so should the room. (I once walked into a photographer's studio in his barn, first thing on a winter morning—it was 60°F in the studio. Not the best conditions for calibrating a display.) I suggest the monitor be on for at least half an hour, with the screen-saver turned off.

Once you start the software—in this case, XRite's i1 Match—we see a screen with various device choices. Select the monitor and the appropriate display type (LCD or CRT).

The next dialog is going to ask you what setting you want to calibrate to. Unless you have a very good reason to select something different, select a white balance of 6500K (or D65) and a gamma of 2.2. I usually set the Luminance value at the suggested default for the display—here, 120 is shown as the LCD standard. If I have several displays in one studio, I make sure they all are set to the same thing.

Eye-One Match 3

Set the Contrast

Help

CONTRAST
70%

Monitors

- Select Monitor Type
- Calibration Settings
- Calibrate Eye-One
- Position Eye-One
- **Calibrate Contrast**
- Calibrate RGB
- Calibrate Luminance
- Measuring
- Save ICC Profile

NORMAL ▷ CONTRAST

CONTRAST 100%

BRIGHTNESS

◄ 1 ►

The first step on calibrating your monitor is finding the best contrast. Most monitors offer the possibility to adjust contrast and brightness. You will find these controls on the front panel or in the OSD (On Screen Display) of your monitor.

Read the following help steps if the controls of your monitor allow you to adjust the contrast. Otherwise click the right arrow to skip this setting.

Set the contrast to 100%.

Start

◄ ►

Now for the Brightness and Contrast calibration—brightness, on a display, is the level of the "black" point, and contrast is the "white" point. I don't know why these terms, but if you look at these brightness and contrast settings in the context of your photography experience, you'll probably be good and confused.

Next is the RGB controls screen. How I handle this depends on what controls my display has. If I have a color-accurate display with true R, G, and B controls on the monitor itself, I use those to dial in a white point of 6500. If not, the software will simply try to correct what it gets.

Once the software runs through these routines it has done a few important things: it has created a baseline setting (a default setting) for the display controls, and it has also linearized the display profile. Remember linearization from page 100? This ensures the display is doing the same thing from dark to light, in a nice linear way.

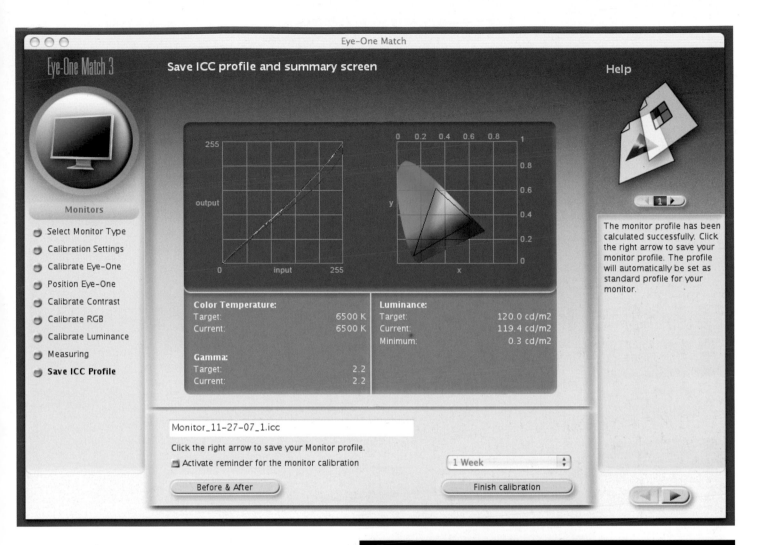

The final step is to profile the display (hit the > arrow, and it starts running this screen) and that constitutes running a scries of color targets, reading them, and building the display profile. It is then named and stored in the ColorSync folder. (I generally do not rename it—I just go with the default.)

Rendering Intents

Rendering intents are the logic used in remapping color into a smaller color space. The two basic rendering intents that we are dealing with are Perceptual and Relative Colorimetric.

Perceptual intent presumes that we want to keep the relationships between all the colors—that is, if you have colors that appear differently, we want to maintain that appearance when they are remapped. Converting colors with Perceptual Intent requires that we move all the colors in the space around a bit. I like to make an analogy to a sponge: Perceptual intent squishes the sponge up, and the entire sponge changes shape a little.

Relative Colorimetric intent is more of a cookie-cutter effect. If colors are outside of the smaller space, Relative Colorimetric moves them to the closest color inside the space. All colors inside the space remain untouched. If, in the conversion, the colors being remapped lose their relationship to each other, or lose their "spacing," so be it.

(A) Here are two examples. I went back to our color burple, and made a couple of other colors; we now have blue, burple, and purple. Here they are, sitting well outside the Epson Premium Luster color gamut (shown as lightly shaded).

(B) The next illustration shows the three colors mapped into the gamut of Premium Luster using Perceptual intent. You can see that the distances between the three are almost exactly the same, and they've been moved around a little. This is to maintain our perception of them, and their relationship to each other.

(C) The final illustration shows the same colors mapped using Relative Colorimetric intent. As you can see, they are closer together and are mapped directly into the gamut to the nearest available color with little concern for maintaining any relationship among them.

So when do you use Perceptual and when do you use Relative Colorimetric? Keep in mind that with Perceptual intent everything gets changed, or remapped. Relative Colorimetric changes only the colors that need to be changed. There's your answer.

It is best to use Perceptual intent when the "look" of the colors is important and you are making big changes. For example, if you have a full, rich blue and purple image and you are printing it to Premium Luster, you might use Perceptual intent so that the colors will maintain the same differences and "spacing" you see

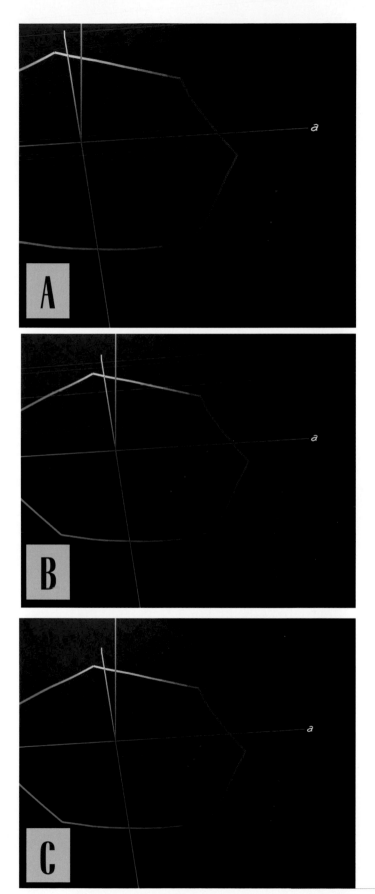

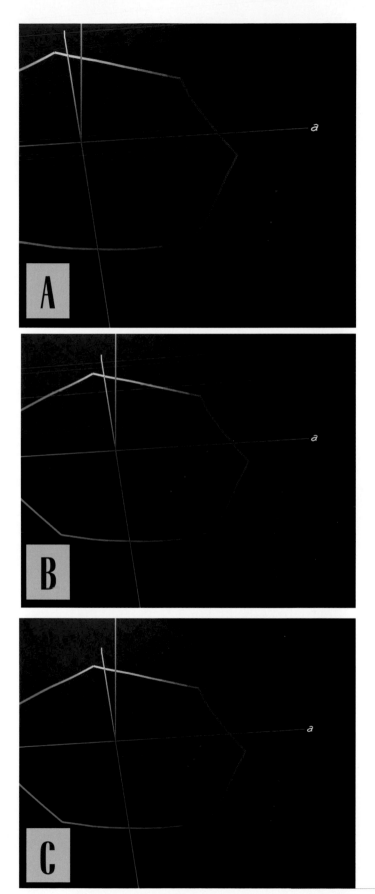

in AdobeRGB, but are mapped into the colors that the printer can produce.

Relative Colorimetric intent is really handy when most of your colors fall inside the printer gamut, and only a few, like our burple, are not within the lines. There is no need to push everything around just to get one color to fit. We just need to push it in and leave it as it sits.

If you know where your colors fall and what your gamut is, you can make the best choice about how the system converts the colors to keep as much of the image intact as possible.

Color Management Settings in Photoshop

The Color Settings dialog in Photoshop is where you determine how Photoshop uses the color management tools in the system. If this is set properly, Photoshop can take advantage of all the controls and options we have discussed. If it is not properly set, a consistent color

management workflow goes down the tube. Let's go through each step of this dialog and see exactly what is happening.

Here is the starting dialog. Go to Edit>Color Settings to see this default setup. The first step is to select the Settings pull-down menu and, instead of North American General Purpose 2, select North American Prepress 2.

This makes almost all the changes we need to make, but most importantly, it sets us up to work in AdobeRGB (1998). I honestly don't even look at the CMYK or Spot settings, because I don't use them, and the Gray setting I just leave at the default. Take a look at the other options.

North American Prepress 2 sets our Color Management Policies to "Preserve Embedded Profiles," and for any mismatches—that is, any time a profile does not match our working space—Photoshop maintains the integrity of the file and asks what we want to do. When this is checked, and you try to work with a file that has a different profile, you'll get a "Profile Mismatch" dialog. This is how I always work because most of my files are in AdobeRGB. If I open a file that is not in AdobeRGB, I want to know about it. That usually happens when I'm opening a file in sRGB, from a client or one of my old files, or I'm opening a file in ProPhoto RGB, and I have a very specific idea of how I want to handle the file.

The next dialog is hidden. Select the "More Options" button and you'll open up a bunch of things, only a few of which you need to consider now. First, you'll see the "Conversion Options," where you can very specifically determine how Photoshop will deal with your colors.

The "Engine" essentially refers to the calculations that the color management system will use to control the color conversions. In an Apple system, you'll have Adobe (ACE) or

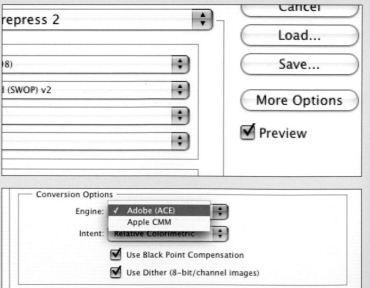

Conversion Options

Engine: Adobe (ACE)

Intent: ✓ Perceptual
Saturation
Relative Colorimetric ...tion
Absolute Colorimetric images)

Advanced Controls

☐ Desaturate Monitor Colors By: 20 %
☐ Blend RGB Colors Using Gamma: 1.00

Description

Perceptual: Requests a visually pleasing rendering, preserving the visual relationships between source colors. Often used to render wide gamut source images, where preserving the relationship of colors inside and outside the destination gamut is more important than exactly matching the colors inside the destination gamut.

Color Settings

Unsynchronized: Your Creative Suite applications are not synchronized for consistent color.

OK
Cancel
Load...
Save...
Fewer Options
☑ Preview

Settings: Custom

Working Spaces

RGB: Adobe RGB (1998)
CMYK: U.S. Web Coated (SWOP) v2
Gray: Dot Gain 20%
Spot: Dot Gain 20%

Apple CMM. In a Windows system you'll have a different choice—it used to be ICM in XP, and now it is WCM in Vista.

The point is that you have the choice of running a standard Adobe engine or running the engine designed by the operating system engineers. My choice here is pretty clear: Adobe (ACE). First, I use this for the purpose of standardization. If you're on a Windows machine or a Mac, and use the Adobe engine, you're using the same engine on both. Whatever system you are on, if you're preparing files that may be used on a computer—and who isn't?—then Adobe (ACE) is the logical choice. Second, there's the issue of effectiveness and usability. Adobe seems to be more predictable and more stable.

The next choice is arguably the most important decision to be aware of, and that is the rendering intent. I'm showing it here, with my suggestion for the default selection of "Perceptual" intent. As we discussed above, the key point to understand is that we are essentially setting our preferences and our defaults. We can use different intents at almost every step, but here is where we set our desired default actions. For example, if you have set up Photoshop to automatically convert files to the working color space rather that ask first, it will use the intent we specify here. Whatever is chosen here appears in any of the workflow windows as the first option.

Refer back to the rendering intents discussion for the in-depth story, but in brief, Perceptual intent keeps the colors looking right, especially in relation to each other, but remaps all the colors within the gamut. Relative Colorimetric keeps the colors in the gamut intact without changing them, and jams any out of gamut colors into the color space. For someone in prepress, Relative Colorimetric is the best bet, since colors are so critical and precise on press. As photographers, though, we are generally more concerned with making the image "look right," and that involves precise color relationships, not necessarily precise color mapping.

Now, save the setting.

As soon as you change anything from the preset, the pull-down menu will show "Custom," simply suggesting you're not in a preset anymore. Hit "Save" and you'll be able to save this

setting and pull it up later. This is great if you're using the same settings on several systems—you can actually load and transfer this settings file all over your network. You could even save this on a portable drive if, for example, you're

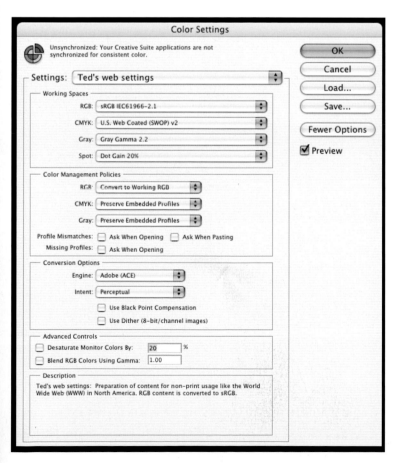

using a system at a school or working among several studios as a production freelancer. Your settings are saved in the "Settings" folder (unless you specify somewhere else when you save them) and they have the ".csv" extension.

Here is "Ted's Color Settings," and here is the location of the file: User>Library>Application Support>Adobe>Color>Settings.

(Are you using Windows? Sorry, but you are on your own. They keep moving that stuff around.)

As you develop various workflows for different purposes, you may find some color settings work better for you than others. I'd suggest starting here with these, but, for example, let's say you do a lot of work on the web. sRGB is probably the most logical working space for web publishing, and it is easier and faster to have Photoshop convert everything to that space using Perceptual intent. If you create a "Web" color setting, you can work faster since you don't have to constantly deal with the "Profile Mismatch" dialog, and if you save that setting you can easily switch back to your higher-quality AdobeRGB setting at will. Here is an example of how I would set Photoshop up for extended web work.

A couple of things I haven't addressed is the "Black Point Compensation" and "Dither" switches, and the last, "Advanced Controls" dialog. These two switches I leave off. They are pretty much for prepress use, and the same for the "Advanced Controls" switches. For us photographers, let's leave them alone and move on.

Creating and Applying Printer Profiles

Printer profiling software is as much about art as it is about science. In this case, it is as much about the art of the software design (how the software is built to interpret and render colors), as it is about the accuracy of printing color. When you play around with different profiling programs, you see pretty quickly that every program does its own thing. Epson profiles tend to create warm skin tones, very saturated colors (especially reds), and not a great grayscale ramp. Other profiles are more accurate—the X-Rite i1 Match software is a model of accuracy—but

sometimes I prefer the rendering of a "prettier," less accurate profile.

Paper profiles—or more accurately, profiling software—are designed to make not just accurate but pleasing renderings of color. Choosing profiling software then becomes a matter of tastes and preferences.

Building a printer profile is pretty simple, as we've seen here. Take a target and measure it. The software builds the profile based on a set of calculations from the differences—or the variation between how the target should appear and how it actually measures.

Start by printing a set of target prints, making sure the printer settings are correct for the paper and the color management in Photoshop, as well as the printer color management in the drivers. X-Rite software prints the target for you, which avoids any "application" level color management, but it's still up to you to make sure the printer driver is set up correctly so it doesn't alter the colors.

Once the targets are printed it's a good idea to wait at least half an hour before measuring them, to allow them to dry fully. Not many people I've talked to can

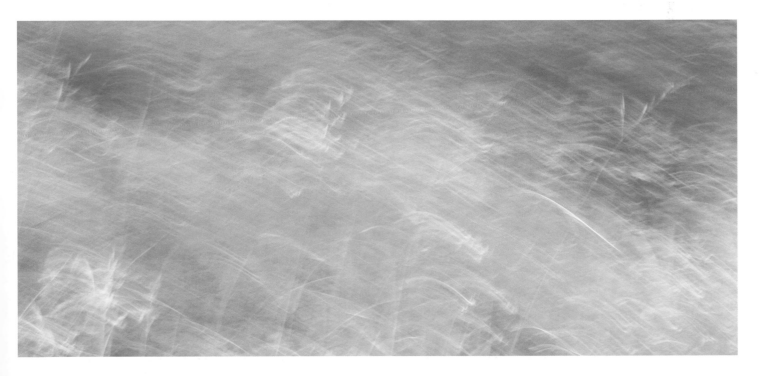

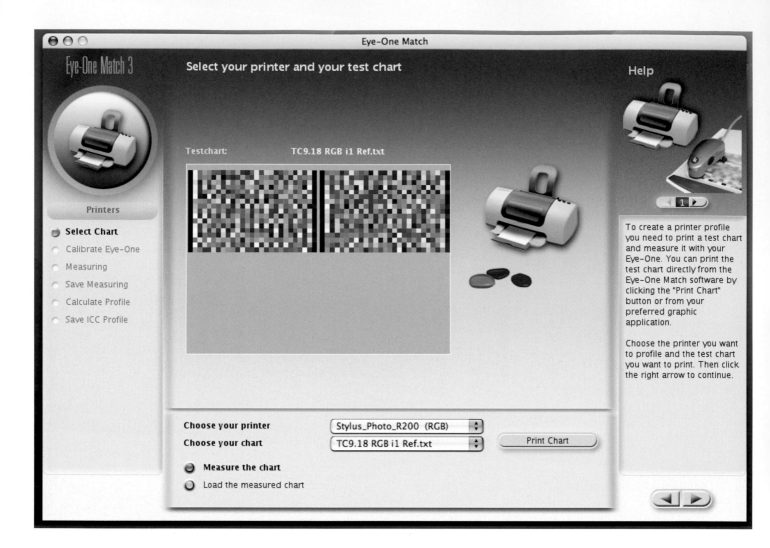

actually claim that the colors change when they dry, but I will say that I have scuffed target prints when I've tried to measure them too soon. If you're serious, you should actually let the print dry for days—even weeks—before running the measurement.

Here is a familiar set of screens. X-Rite i1 Match asks for the type of printer you need a

target for and prints it for you. When you get to the "measure" screen, it is a simple matter of running the colorimeter over the target's color patches and recording the measurements. Back in the day, the software would let you get through almost all the measurements and then error out or crash. Software is much friendlier now—you can miss a strip, even forget what

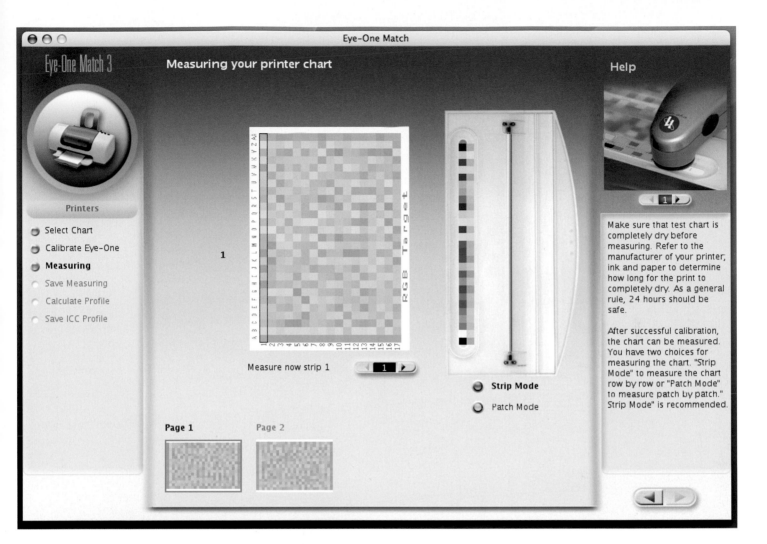

you've measured and what you haven't, and it reminds you to measure the missing color patches. It feels a lot like agitating film—repetitive work, little concentration needed, and almost soothing. Once it is done measuring, the software loads that target profile in the ColorSync folder and you're done.

Using the Profile

Once you've created the profile, you must start—or re-start—Photoshop. When Photoshop is re-started, it sees the new profile. From there you can use it just as you would a stock Epson profile: print, set up the profile in the color management dialog, and turn off the color management in your printer driver.

HINT: Think along the lines of "digital hygiene"—or the more industry friendly "media management"—when you create new and updated profiles. I recommend sitting down with a cup of coffee and giving some long hard thought to how you will name them. They should be clear and should group themselves so you can find them fast and efficiently. Bill Atkinson, a software engineer by training, goes through a whole discussion of his naming strategy in his "Bouquet of Profiles" pages (http://homepage. mac.com/billatkinson/FileSharing2.html under "Bill's Profile Names"). Like your Mom always said, put your stuff away nice and neat, and you'll be able to find it when you need it.

Here is where you tell Photoshop to handle color management, rather than allow the printer driver to have the control. This dialog shows you how to do that; I'm using the "HPZ310gloss" profile I created specifically for the HP Z3100 printer.

Summary: Color Controls

For some, profiling may be a long, tedious and technical voyage. It is not for nothing, though—the point of the explanation is to come to grips with the process, and how we can drive it rather than be driven by it.

Here is a quick synopsis of each step of the color management journey in terms of profiling. This is where the importance of consistency truly arises. I'm going to rate each move as follows: "Basic/ Required" for the items that everyone needs to do; "Intermediate" for those things you can do, it might help, and may guide you along the road a bit; and "Advanced" for stuff that you need in order to know what is going on under the hood.

Digital Camera Capture

▶ Control exposure and camera settings (Basic/Required)

Camera Profile Input in the RAW processor

▶ Use alternate profiles with some camera-specific software (Basic)

- Build your own camera profile (Intermediate)
- Customize your own camera profile (Advanced)

Color Settings in Photoshop

- Set to standards (Basic/Required)
- Create your own policies (Intermediate)

Working Color Space

- Set to standard (Basic/Required)
- Use "custom," e.g. Joe Holmes' DCam space (Intermediate) (see page 44)
- Design your own (Advanced)

Display Profile

- Calibrate Monitor (Basic/Required)

Printer Profiles

- Set in Photoshop (Basic/Required)
- Use "Custom" profiles (Basic)
- Build your own (Intermediate)
- Customize your own (Advanced)

My best advice is to play around, take a look at the options, invest in some good software like the i1 Match system, and play some more. Some parts of the system may seem overly complex, some parts may give you no yield at all, and some may change your life. Dive in, mess around, and keep in mind this basic path of digital color throughout your color management system.

*T*he ICC profiles are loaded from several places in the system. At first I found this really annoying, until my own comments—about how every blessed ICC profile in the system is loaded into one folder, making it impossible to find and manage them—came echoing back to me. As my buddy Nick says, there's nothing worse than having your own pithy sayings (or in this case, complaints) thrown back in your face, but so be it.

(A) If you download profiles for a printer, or make your own, they get loaded into your system Library in the ColorSync folder (Macintosh HD> Library> ColorSync> Profiles).

If you have installed your Epson printer, the accompanying profiles go into a kind of hidden container "package." This does not allow you to do a search for the things inside the package—in this case, the printer's standard profiles. You have to go to the package and look inside to find what you need. Here's how you do that.

(B) Go to Library>Printers>EPSON/SPR2400.plugin.

(C) Select the SPR2400.plugin, left-click on it, (or ctrl-click), and you'll get this menu.

(D) Click "Show Package Contents," and you'll see the inside of the folder. From there, go to Contents> Resources> ICC Profiles, and you're there.

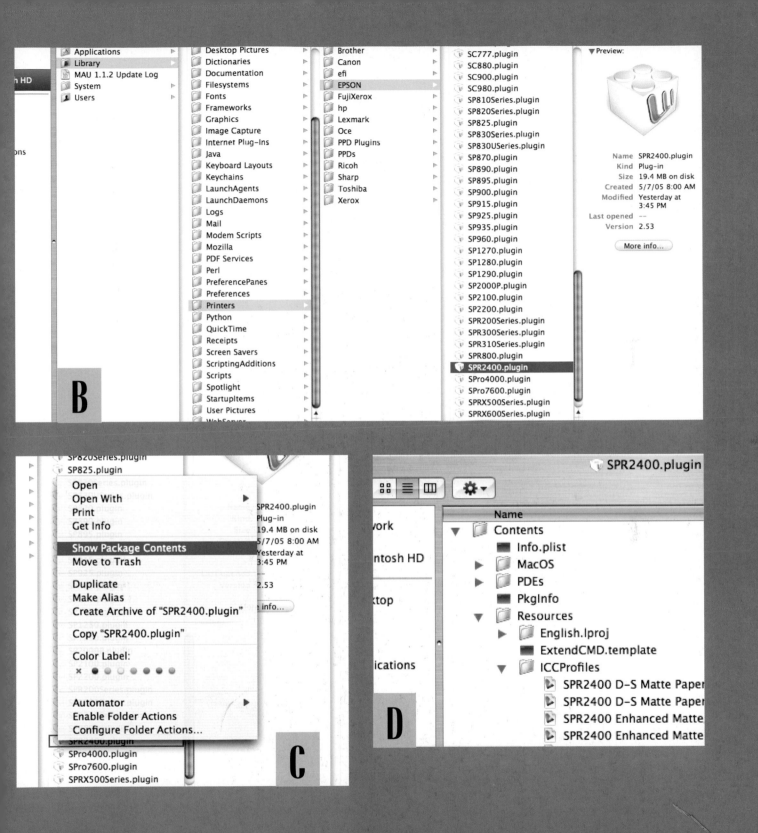

B

Applications	►	Desktop Pictures	►	Brother	►	SC777.plugin
Library	►	Dictionaries	►	Canon	►	SC880.plugin
MAU 1.1.2 Update Log		Documentation	►	efi	►	SC900.plugin
System	►	Filesystems	►	EPSON	►	SC980.plugin
Users	►	Fonts	►	FujiXerox	►	SP810Series.plugin

h HD

Applications
Library
MAU 1.1.2 Update Log
System
Users

ons

Desktop Pictures
Dictionaries
Documentation
Filesystems
Fonts
Frameworks
Graphics
Image Capture
Internet Plug-Ins
Java
Keyboard Layouts
Keychains
LaunchAgents
LaunchDaemons
Logs
Mail
Modem Scripts
Mozilla
PDF Services
Perl
PreferencePanes
Preferences
Printers
Python
QuickTime
Receipts
Screen Savers
ScriptingAdditions
Scripts
Spotlight
StartupItems
User Pictures
WebServer

Brother
Canon
efi
EPSON
FujiXerox
hp
Lexmark
Oce
PPD Plugins
PPDs
Ricoh
Sharp
Toshiba
Xerox

SC777.plugin
SC880.plugin
SC900.plugin
SC980.plugin
SP810Series.plugin
SP820Series.plugin
SP825.plugin
SP830Series.plugin
SP830USeries.plugin
SP870.plugin
SP890.plugin
SP895.plugin
SP900.plugin
SP915.plugin
SP925.plugin
SP935.plugin
SP960.plugin
SP1270.plugin
SP1280.plugin
SP1290.plugin
SP2000P.plugin
SP2100.plugin
SP2200.plugin
SPR200Series.plugin
SPR300Series.plugin
SPR310Series.plugin
SPR800.plugin
SPR2400.plugin
SPro4000.plugin
SPro7600.plugin
SPRX500Series.plugin
SPRX600Series.plugin

▼ Preview:

Name SPR2400.plugin
Kind Plug-in
Size 19.4 MB on disk
Created 5/7/05 8:00 AM
Modified Yesterday at
3:45 PM
Last opened --
Version 2.53

More info...

C

SP820Series.plugin
SP825.plugin

Open
Open With ►
Print
Get Info
Show Package Contents
Move to Trash

Duplicate
Make Alias
Create Archive of "SPR2400.plugin"

Copy "SPR2400.plugin"

Color Label:

✕ ● ● ○ ○ ● ●

Automator ►
Enable Folder Actions
Configure Folder Actions...

SPR2400.plugin
SPro4000.plugin
SPro7600.plugin
SPRX500Series.plugin

SPR2400.plugin
Plug-in
19.4 MB on disk
5/7/05 8:00 AM
Yesterday at
3:45 PM
2.53

e info...

D

SPR2400.plugin

⊞ ≡ ▥ ✿▾

Name
▼ 📁 Contents
 ■ Info.plist
 ► 📁 MacOS
 ► 📁 PDEs
 ■ PkgInfo
 ▼ 📁 Resources
 ► 📁 English.lproj
 ■ ExtendCMD.template
 ▼ 📁 ICCProfiles
 SPR2400 D-S Matte Paper
 SPR2400 D-S Matte Paper
 SPR2400 Enhanced Matte
 SPR2400 Enhanced Matte

vork
ntosh HD
ktop
ications

PART 5:
THE OPEN ROAD: COLOR WORKFLOW IN THE REAL WORLD

et's take a look at real-world application of the techniques and workflow we have zeroed in on up to this point, as well as detail the remaining steps and considerations of a consistent color managed system.

14 HANDLING CAMERA COLOR

Let's look at some real examples of handling color. Assume I'm using a camera that is fairly new or one with which I'm unfamiliar. The first step will go one of two ways: I can test the camera to see how it responds in various situations, so I'll wander around shooting the ColorChecker under all sorts of lighting conditions; or I'll just shoot it on the set for a job I'm trying to get out the door, and start from there. The studio is a good place to start—with daylight lighting (studio strobes) in a controlled environment. As I use the camera and become more accustomed to its response, I can determine if my calibration holds up.

Here is a look at my typical studio shoot. The first shot is the ColorChecker, and then I dive into shooting the products. The trick here is to make sure the chart is shot and exposed correctly—not over- or under-exposed—and not reflecting any strong colors. This is a white background. If I had been shooting it on a bright red background and it was catching reflection from the background, I'd have a reddish cast to it and it would be useless. I start off by opening this target up in Camera RAW.

This is what I see with Camera RAW working at its default settings. Assuming my display is correct, I can get a pretty good feel for what is happening to my RAW file of the color target. To pick out one simple example, look at the red patch near the center—it looks really magenta and too saturated. I click on the neutral tool and balance the color cast of the target by clicking one of the gray patches on the card. This neutral rebalancing starts me off with a good idea of how to adjust the file. Here is what the rebalanced image looks like.

If I clean up my neutral values right away, the colors map pretty well. But I still feel like my red is too saturated, and too magenta. To fix that, I will go into the "Camera Calibration" tab.

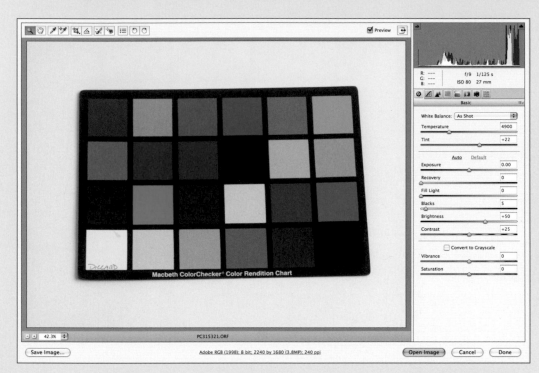

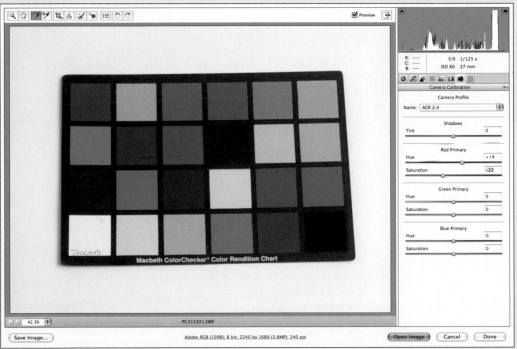

This tab deals only with the three basic color channels from the camera's sensor: red, green, and blue. It allows me to adjust the hue and saturation of each channel individually. Here, I've gone into that tab and turned my saturation down. I've also pushed it over to orange-red, and away from magenta-red. Here is that tab and the resulting adjustment. Just making this adjustment visually on a good monitor, with consistent calibration, I can see the rendering of my color is more accurate. This is a good place to start, and I want to save this setting as my default setting so that Photoshop applies this every time I work with the image files from this specific camera.

There is only one hitch, though. I want to apply this setting without the first adjustment I made, which was setting the white balance. I'm going to go back and change the White Balance menu

selection to "As Shot." The reasoning is that I'm trying to create a general calibration setting for this camera, not one specific to this lighting setup. I want to get a feel for what my camera does every single time—I'm learning that it is always going to map the red this way (too saturated, too magenta), regardless of my shooting situation. I'm just trying to modify that in a global way so that I can rely on the "default" processing in Camera RAW to handle these camera files correctly every time. The White balance does not really play into that, therefore it is not on the "Camera Calibration" tab. So go back, undo the White Balance by selecting "As Shot," and save those settings you've made in the "Camera Calibration" tab.

Go to the "Settings" pulldown, which is somewhat hidden in CS3—or at least not really labeled. (It is the little camera

icon in the upper right.) Pull this down and select "Save New Camera Raw Defaults," and you have set this as the default adjustment. Adobe Bridge will preview the files with this setting applied, and Camera RAW will start you off by making that adjustment.

If you ever want to go back to the default Photoshop processing, go to the Settings pulldown menu and select "Reset Camera RAW Defaults," and bingo—back to the factory settings.

NOTE: In the Settings menu, you also have the option to "Save Settings." I highly recommend saving your settings, especially if you are building a library of profiles for your camera. For this example, I would save this setting as "E10strobe." Then, if I notice that the camera reacts differently with other lighting scenarios, I can tune the settings and save those too. Suppose I notice that the blues pick up saturation under sunlight to an objectionable degree. I start with my E10strobe, desaturate the blue, and save that as a new setting: E10sun. I can then apply these presets at any time by selecting "Apply Preset" and choosing the one I want. After a few months of shooting with this camera—as long as I have shots of my ColorChecker—I'll have a nice variety of presets I can apply to my images for any lighting situation.

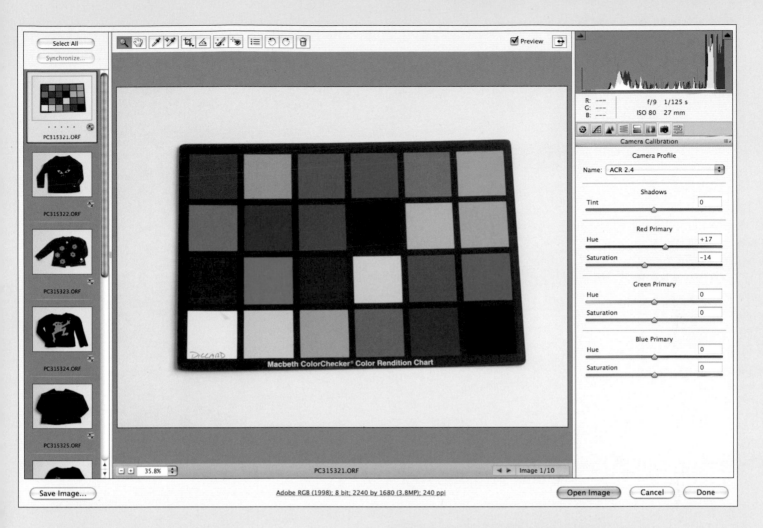

Applying the Presets

Whatever you have chosen as the default setting determines not just how the files will look in Adobe Bridge, but how Camera RAW will process them. Remember, the purpose of this profiling—or calibration—is to correct image discrepancies automatically regardless of what or where you are shooting—simply fixing the camera's bad habits. So here we go.

Select all of the files you want to work on in Photoshop. Open them all at once, in Camera RAW. If you have set your "profile" as your default, the files will all open with that basic Camera Calibration adjustment made, but will not be neutrally balanced.

Select the Neutral Balance eyedropper tool and click one of the middle gray patches; you should have a lovely looking file. Then, in the upper left, click "Select All," then "Synchronize," and this applies that setting to every open image in Camera RAW. (I click the middle gray patches because, well, it's in the middle.)

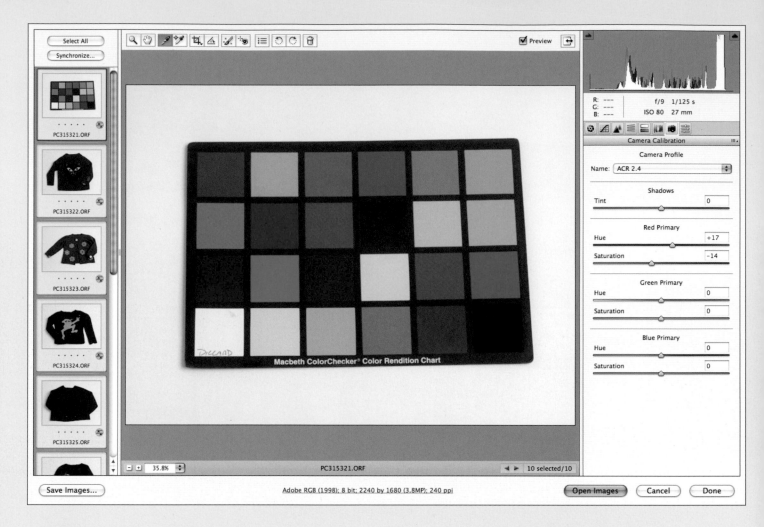

NOTE: Your neutral adjustment will almost always drift slightly—it is not perfectly linear. If you click the white patch, it has five patches to drift through on its trip to black. Let's say it drifts 2 points for every step, that is a drift of 10 points by the time it gets to your black tones. If you click the middle, it only has two or three steps to drift. The most it can drift is 4-6 points off the neutral point you've selected. Again, think in terms of establishing a middle point and mapping around that point. (In class, I use the example of laying tile—always start in the middle of the floor and lay the tile out from there.

If you're not straight, it will be half the error when you finish than if you start from one edge and lay to the other edge. This analogy is always met by looks of utter confusion and dismay. Apparently not many photo students watch much in the way of home remodeling TV shows.)

After choosing the middle gray with the neutral selection tool, you have a range of nicely mapped color. Every time I do this for a different set of files, I take a good look at the settings in the Camera Calibration tab and try to tighten them up until I have what I feel to be a good, general "calibration" of my camera.

It is easy to get carried away with this, but I suggest you do not. Bruse Fraser goes through this whole exercise on how to adjust the ColorChecker patches, patch by patch, to what their values should be. It is my opinion that there is a fine line between too little calibration and too much. Too much calibration gives you a better, tighter "profile," but also one that is less flexible in how and where you can use it. I'm looking for a nice balance of a good correction that fixes my camera's bad habits in a way that I find pleasing, without being too specific to the lights and environment in which I'm shooting.

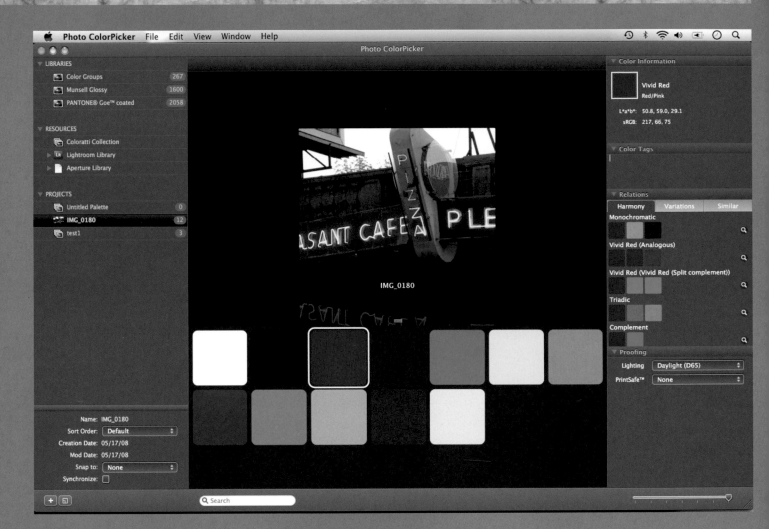

ColorMunki, by XRite, has a great bundled application called Photo ColorPicker—a tool for analyzing and matching colors in layouts and illustrations, for example, with the photographs on the page. It is also a great way to illustrate the various ways colors relate, far beyond simple complimentary or adjacent color theory.

The first step is to load the photograph into the "Projects" list. Photo ColorPicker will sync up with your Aperture and Lightroom libraries, but you can also bring in images one at a time or in groups. Once loaded, the image is analyzed and broken down into basic groups of patches. Notice the section on the mid-right of the main workspace page, the "Relations" tab. This is a great illustration of what we were looking at—the color palette of an image, but also other colors that are related to our image colors. Here are some "generations" of my selection, "Vivid Red."

The first tab is a listing of the various colors in "Harmony" with my selection: Monochromatic, Analogous, Complementary, Split Complimentary, and Triadic. We then can see "Variations" and "Similar" colors in the next two tabs.

Photo ColorPicker has a whole lot more, including a feature that allows a designer to find other photographs in the Library with similar palettes—a very useful design tool indeed. For our purposes, it is a great tool for distilling our image into its color palette.

Understanding Paper

Surprisingly, the single biggest thrill I get from the digital photography revolution is not Photoshop or digital capture, but from the freedom I have in choosing a paper for printing images. A large part of that comes from my background in printmaking. Much of the work I did back in school was in woodblock, silkscreen, etching, stone lithography, and mezzotints—all processes ending with laying ink on paper. The other place that comes from is just my frustration with photographic paper. I always felt that photo paper—even the high-end fiber gallery paper—just didn't feel like paper at all. Resin coated paper, for both black-and-white and

color darkroom printing, didn't feel like paper either.

Digital photography almost immediately gave me the ability to print on any type of paper I could imagine. In the early days of the Epson Stylus Photo printer—the very first Epson photo printer—I went through all sorts of processes attempting to get good prints from regular watercolor paper and different types of photo and non-photo papers. Then a few companies offered true photo-quality watercolor papers for use with these printers, producing amazing photographic quality prints on paper that felt like actual paper.

The prints became closer and closer to what we consider archival. For a while, there was a tradeoff between the ability to print a full gamut of colors for a print that lasted more than a few years. Today we can make a print that is every bit as rich as a traditional print and will last.

A good friend, Walt Levison, had a fascinating career in developing some of the earliest satellite photography equipment. (One part of this satellite photography development was the satellite that produced the photographs used in the Cuban Missile Crisis, back in the 1960s, that gave President Kennedy enough information about the actual situation in Cuba to play the hand that he did. But I digress.)

Walt was an avid photographer, and went on to be a venture capitalist, funding an interesting company—Iris. They made the first printers that were capable of printing ink on paper from a computer. These printers, developed for press proofing, tantalized the photo community. They showed what could be done—in fact, Graham Nash and his team at Nash Editions immediately voided the warranty on their $60,000 Iris printer to alter it so they could print on fine-art watercolor paper. These prints were amazing, but they had an archival life of around 5 to 10 years if stored properly—hardly archival quality by most standards.

One of the interesting things about the Iris printer is that it puts down a whole lot of ink, and, thus, can print on a normal paper. Epson ink jet printers do not; they actually squirt a very small quantity of ink, and if you're printing to a watercolor paper, it gets soaked up and looks bad. Unless that is the look you're going for.

Producers of ink and ink jet paper have actually a created ceramic material that coats the paper, essentially sealing it. The ink does not soak in; it

sits right on the top of the coating. That coating is what gives the printer the ability to spray such a miniscule amount of ink while still producing a rich gamut of color.

Ink jet ink and ink jet paper are a precise mating of materials. As much as I love to play around with unpredictable and unusual combinations of machines and methods, I rarely mess with papers and inks. I almost exclusively use Epson Ultrachrome inks because they produce the highest gamut of colors in the most predictable way, producing an archival print. The paper the ink sits on is paper that is designed for use with this ink, whether the paper is Epson paper or not. The ceramic sealing on the paper has to behave well with the ink at a basic, chemical level.

The selection of papers built for these printers and designed to work with these inks is now, thankfully, huge. Not only that, most papers made by any major manufacturer now come with ICC profiles—easily downloaded from their websites—so you can work in a fully color-managed workflow despite not being able to custom profile a paper.

Walt would be so excited. We now have almost any imaginable paper type and surface to use, and we can use it in a consistent, repeatable way, producing the highest quality results.

Choosing a Paper

Paper choice is far from a scientific decision—it is based as much on personal taste as anything else in photography. There are some facts, however, that can help you make this decision more easily.

Paper Type and Surface

The first and most obvious factor to consider is the paper type and surface, although this brings up issues. While showing friends some prints, Bill Atkinson pointed out that Epson Premium Luster paper has the richest black and fullest gamut of any Epson paper. Although he loves the texture and feel of a paper like Crane Museo or Epson Ultra-smooth Fine Art, he argues that once the print is framed and behind glass, the surface texture no longer matters. He wanted the fullest print possible, so he used the paper that gave it to him.

This torments me; I love a full, rich print, but I also love printing on a watercolor paper. I feel I have to make a tough compromise here—ultimately, I let the photograph dictate my paper choice.

To illustrate this, let me give you an example. I make blurry pictures. They feel like water-color paintings, and I love watercolor paper, so I usually print them on some form of fine-art watercolor paper. The first good paper I used was Somerset Velvet, which was later packaged as an Epson paper. I spent a few years messing with various papers (Crane Museo, Hannemuele Photo Rag, to name a few). I had pretty much decided that a "photo" paper like Premium Luster or Gloss was not for me.

Then I printed some 4 x 6 inch (10.2 x 15.2 cm) postcards for a show, on Epson postcard paper (which happened to be Premium Gloss), and they knocked my socks off. The prints of my favorite and very familiar images were somehow new and completely amazing. I looked at them with fresh insight. The bottom line is to try it; you may be surprised.

It is important to understand that the paper type and surface determine how the ink will be absorbed, and how vibrant the tones of that

ink will be. A high-gloss paper will have the ink practically sitting on the surface—you can even see it if you hold the paper at a certain angle. As a result, the paper delivers a very full, rich print.

A softer paper, such as UltraSmooth Fine Art, absorbs more ink and yields a softer print. This may be a good thing or bad thing, depending on the image itself. You can see how the image will appear on this type of paper by looking at the gamut maps of the paper profiles.

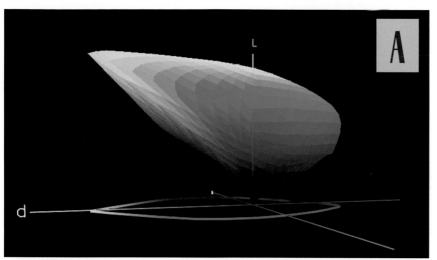

(A) Here is the profile for Epson Ink Jet Photo paper. It is a very useable paper, and really nice for making work prints—something I strongly encourage my students to do. It is also relatively inexpensive.

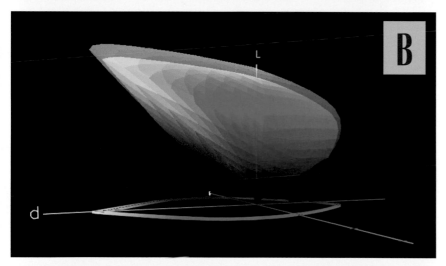

(B) Here is the Ink Jet Photo paper again, but with Epson UltraSmooth Fine Art paper dropped over it and ghosted for comparison. It is pretty close, but you can see pretty clearly that the UltraSmooth Fine Art will hold more of the brighter end of the gamut (the Luminance axis), especially in the yellows and oranges. If I am ultimately printing on UltraSmooth Fine Art, but using Ink Jet Photo for my work prints, I'm going to try to keep this in mind, especially if my photograph has a lot of yellows.

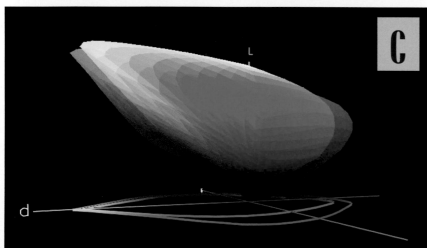

(C) This is the gamut map of Epson Premium Luster paper superimposed over the UltraSmooth Fine Art paper gamut map. It clearly gives me more colors, in almost every direction, but

more so in the red, blue, and green midtones.

(D) This is the Ink Jet Photo paper gamut from another angle.

(E) Here is the Ink Jet Photo and UltraSmooth Fine Art paper alternate angle comparison.

(F) This maps the three paper choices together.

(G) This mapping shows the three paper profiles together from a slightly different view, and clearly shows the gain in color gamut by using Premium Luster. If my image has a lot of greens and reds, I'm going to think long and hard about using this paper instead of anything else (or, I'll make some test prints).

You may feel like you have to run out and buy a program like ColorThink to make these illustrations—and I would suggest you do this only as a tool to learn profiling—but the fact is, you have access to similar graphs in any Apple system with the Apple ColorSync Utility, and you can compare and contrast papers pretty easily. To plot an actual photograph on this illustration—and see if your image falls within the gamut of your paper—you need ColorThink.

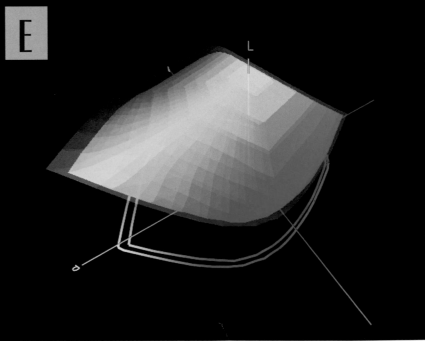

You can use Photoshop to compare papers and plot image colors to see if any fall outside of the gamut of the paper. We'll go into that a little later—on page 170—but you do it by using the "Proof Setup" and "Gamut Warning" controls.

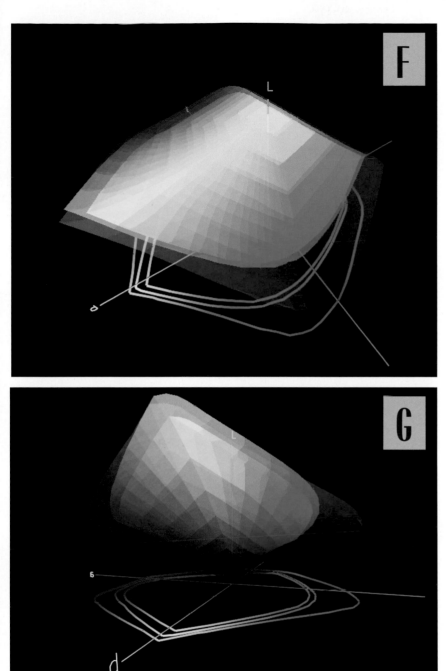

Paper Brightness

Another important part of paper selection is the brightness of the paper. You cannot get a whiter white than the paper's white. I know that sounds like an obvious statement, to the point of maybe being silly, but it is something that we often don't consider. If I want a print with sparkling, clean highlights, I have to have a paper that has a bright white. You can literally lay papers on top of each other and compare their brightness, or you can measure them, but all you really need to do is lay them down together and look to see which is whiter.

One little hitch with this method of comparison is the habit of some manufactures to add a "whitener" to papers to make them that much brighter. These whiteners are called Fluorescent Whitening Agents, and they are used in everything from fabrics to plastics. This creates some problems. First, the whitener may mildly fluoresce under some light sources, creating an unnaturally bright white. If you are printing on these papers and judging your prints under a fluorescent light, you may be disappointed in the result under different lighting. The other issue with added whiteners is the fading of that whitening agent over time. Paper archival ratings don't

evaluate the whiteners fairly—you may get some unpleasant surprises on some papers after a few decades. (Please don't say you don't care because you won't be around to see it. If you're being a responsible printmaker, this is a serious issue, and fine digital printing has taken a huge hit from the outset by way of printers and manufacturers dismissing the issue.)

Here is an interesting tidbit to put the whitener issue into perspective. Some of Ansel Adams' most treasured prints were made on papers that used whiteners, and are still considered some of his best and most vibrant prints, in spite of the fact that the whiteners probably do not add much to these prints now.

The bottom line: if in doubt, use a paper that employs no whitening agents—a feature they generally hasten to list on the packaging.

Just for the sake of mixing it up a bit, let's look at a very unique paper—Crane Silver Rag. Here is a paper that is not very bright at all. In fact, the base paper tone is visibly muted, even a little brown. It has a feel like old-school photo paper (specifically, Kodak's 1960's vintage Kodabromide). It has a fairly standard gloss/luster-type gamut, but this paper is, well, simply yummy. I suspect it's that the paper has a true "fiber" look to it, but with a good tight gamut. Honestly, I don't know what it is about this paper that I love so much. Thus, my statement at the start of this discussion—the decision is as much about emotion as it is about science.

Making the Choice

For almost every aspect of photography I work with, I preach to "keep it simple." I suggest the same approach to paper selection to a certain degree, but when working with papers, nothing works as well as making prints and comparing them by eye. My own approach is to be fairly selective about what papers interest me, and put them through their paces, just like I used to work in the darkroom. Ink jet paper is less expensive though, and there is a lot to be said

for having a good stock of them to choose from. Buy some sample packs, try them out, and compare them over time. I'll often tell students to make a bunch of prints and stick them to the refrigerator. You look at them every time you go to get a beer and after a week or so, you'll know which one you like better.

Once you've done that, I can't stress the importance of then limiting your selection to a few papers. The goal here is to intimately know the papers you're using, and the purpose of that is to help you learn to visualize the photograph. Here is an example: I'm out shooting vivid neon lights at a state fair and I'm seeing Premium Luster in my mind—vivid reds, greens, and blues. I've worked with that paper so much that I can see it at the moment I take the photograph. I expose and process the image for that goal—the final print. On the other end, if I'm at the beach and my subject has soft, warm tones of brown, tan, and light green, as with beach grass, I visualize a print on UltraSmooth Fine Art paper.

Try them out, narrow them down to your favorites, get to know them, and build them into your visualization process—the process that should begin the moment you look through your camera's viewfinder.

Proof Setup and Gamut Warning

Proof Setup allows you to get a sneak preview of how the image will look once you've applied a profile. If you're printing your image on Premium Luster paper, you can try to see the change using Proof Setup. It doesn't work very well (at least, not better than a test print), but with the addition of Gamut Warning—which flags colors in your image that will go out of the color gamut when you switch profiles—it gives you a great tool to flag the colors that might get lost in the shuffle.

Earlier I mentioned that you can check your paper's gamut to see if you have colors that the printer can't handle, and I also talked a little bit about this in the Color Journey section (page 55). By handling Photoshop's display of profile connections and overlaps, you can see if there are going to be issues when printing to a certain type of paper, and this streamlines the decision in paper choice. Here's how this works.

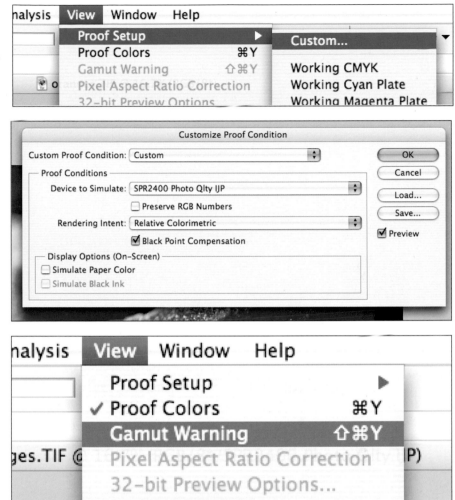

First, open your image and make the editing adjustments necessary to suit your vision of the image. In order to see how your adjusted image will work with a specific paper, go to View>Proof Setup>Custom and pick the RGB profile for the paper you want to test. Here, I selected Photo Quality Ink Jet paper in the "Device to Simulate" drop down menu (shown as SPR2400 Photo Qlty IJP).

I don't particularly care about the "Preview" option, as it only shows me the image onscreen as it might appear on the paper, and there is simply no way to judge an electronic version of a print—one is made with light and the other with ink. Instead, I want to see if the colors in my image can be reproduced on the paper I have chosen. The point of this soft proofing method is to display a gamut warning so there is no doubt what will get lost.

Definitely, though, do not check "Preserve RGB Numbers." ("Preserve RGB Numbers" is an attempt to "proof" the image as if you were going to the printer with no color profiles applied, essentially not color-managing the image. I'm not sure if it ever is workable checking this, but certainly not for our purposes.)

Now, hit OK, and go back to View. This time select Show Gamut Warning.

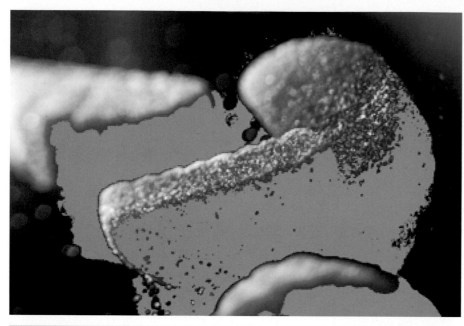

The gray tinted areas show the colors that are out of gamut and will not translate well to this particular paper. I'm sure now that this print is going to look pretty bad on Ink Jet Photo paper. I may still rip a few work prints on that paper, but I'm not going to pay much attention to these areas where the colors are out of gamut. I really want to print this image on Premium Glossy paper, so I can make the same moves to see if that paper can hold these colors. Based on the gamut maps we've seen, my guess is that Glossy will hold these.

Once again, go to View>Proof Setup>Custom. This time, I select the Premium Glossy paper profile. Right off, even without closing this menu, I see that my gamut warning has changed. I see no visible

This gives you a solid color overlay of all the areas of your image that are within your working color space, in this case, AdobeRGB 1998, but fall outside the gamut of your printer and that paper. Here's what our photo looks like.

areas of the image that are flagged, and I can actually toggle around to other papers to see what is going to work best. For now, I'm just selecting my glossy paper and hitting OK. There, right in front of you, is a vivid graphic display of the difference between one paper and another.

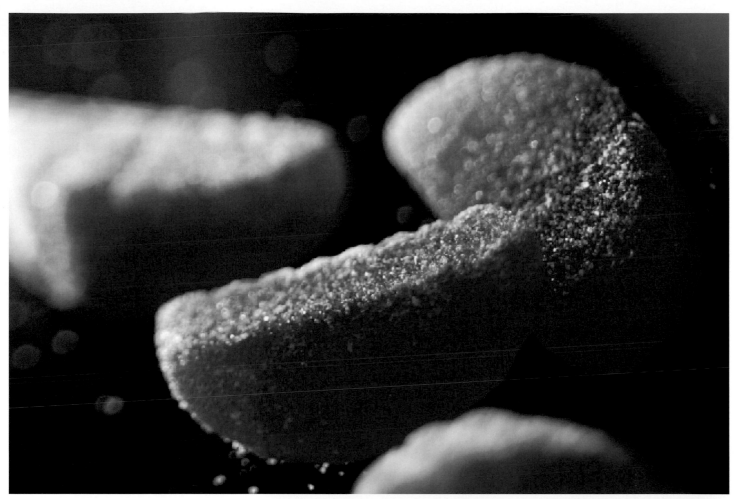

Here's my baby proofed on Premium Glossy paper, with the Gamut Warning on. No problems.

Now, just to be difficult, I want to see what this gamut will look like with the UltraSmooth Fine Art paper. One more time, I go to View>Proof Setup>Custom and make my paper selection.

Ouch. Remember our gamut maps from page 165 that

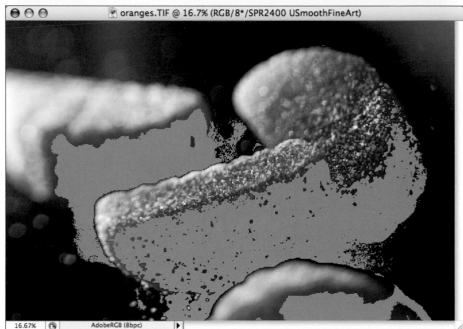

compared the three papers? This is giving us exactly what we should expect after seeing those maps—in this color range there is very little difference between UltraSmooth Fine Art and Ink Jet Photo. This makes my decision an easy one—I'm going with the Premium Glossy paper.

I've included the frame around the image that plainly shows all the color management information. At the top it says we are viewing the image in the SPR2400 UltraSmooth Fine Art paper profile, and that our working color space is still AdobeRGB 1998, shown on the bottom left margin.

Adjusting Colors Into Gamut

Let's say for argument's sake that I really want to print this image on UltraSmooth Fine Art paper, despite its limitations in reproducing the image. I can do two things. One option is to leave the color management to the machine and to the policies I have set up in my Color Settings. (Remember that on page 61, where we set the rendering intent to Perceptual? This is where that setting is used.) If I simply push this out to my printer, the Color Management Module (CMM) will map the colors from outside the gamut of the printer to within the gamut of the printer.

The other option is to do it myself. With the gamut warning turned on, I'll select some adjustment method. For this example, I'm going to use Hue/Saturation to pick that one color that is out of the paper profile's gamut and try to adjust it back in.

I've set up an adjustment layer for Hue/Saturation, and pulled down Edit: Reds. I then took the eyedropper and selected the areas that are out of gamut. Now, I can adjust the color to see if I can bring it into gamut in a way that I like, rather than the way CMM would handle it. I have the three sliders to do that, and that is what is so nice about doing it yourself—you can make very deliberate moves to suit the image. Here we go.

I've pushed the Hue slightly over to orange and decreased the Saturation. I've also made it a little lighter. I'm getting the tones and

colors I like in the important part of the main subject, and although the colors are still a bit out of gamut in the shadows, that doesn't really matter to me.

I've made very deliberate, informed moves to make sure my print has the look I want, in the areas that I want.

There is an alternate way to adjust the image into this specific gamut—using Smart Objects.

Here's my image, opened as a Smart Object. (For more on Smart Object Workflow, see the GeekZone section on page 178.) Again, I go to View>Proof Setup>Custom to set my paper and turn on the gamut warning.

By double-clicking the Smart Object icon, I open up my Camera RAW dialog. Here I have to employ a trial and error technique, but here is also where I use what I've seen from ColorThink's gamut map. I know that this image has to move over and in to make it on the paper, so that is what I try to do.

I lighten it a bit, and move the colors over to orange, away from magenta, with the Temperature and Tint sliders. I also decrease the Saturation a hair. Bingo—into the gamut we go.

A Smart Object is a sweet new device that allows you to get back to all the qualities of the original file. You can use it for several kinds of files—one of which is a RAW image file. The concept is really pretty simple. A Smart Object acts as a direct link to your original RAW image by embedding the actual RAW file as a layer—you can go back to the RAW file via the Smart Object to adjust the original in whatever way is necessary.

The Smart Object sits as a layer in your image. You access it by double clicking the icon, and it re-opens the layer as the original RAW file. Here is a quick step-by-step primer.

Open a RAW file. When Photoshop opens it, it will open the Camera RAW dialog. At the very bottom of the Preview window you'll see what looks like a webpage link, underlined and colored as blue—that is the button to your workflow options. Click it.

This transports you to Photoshop's main screen where, with your layers palette open, you'll see your image with this cute little icon. Double-click that icon, and you are right back to Camera RAW and your RAW adjustments, where you can make changes to the RAW file, save them, and apply them immediately to your image layer. How cool is that?

The Smart Object workflow is a huge revolution. They are extremely flexible layer tools, and you can do anything to them that you can do to any other adjustment or image layer. My next book is entirely about Smart Objects and using that technology to optimize your image adjustment workflow. For now, though, we will concentrate solely on an efficient color managed workflow.

There you will see the box "Open in Photoshop as Smart Objects." Check it.

When you hit OK to return to the Camera RAW screen, you'll note that the "Open Image" tab now reads as "Open Object." Hit "Open Object."

Change Your Mode, Change Your Space

Changing from one working color space to another in Photoshop is easy: go to Edit>Convert to Profile, and choose the space you want to convert. This re-maps the colors to a different volume and with possibly different rules. (This a great place to get tripped up about the true meaning of "Profile" isn't it? We're converting to a working color space—which is technically an ICC profile—but not at all the same as a display profile or an output profile.)

It's important to understand that you are making a conversion, one that makes changes to the

file. In that sense it is a destructive edit—you can't go back by just converting to the original color space. Haphazardly converting from one space to another space is not a great idea, and certainly not something to be done repeatedly on the same file.

(Refer to the GeekZone section on page 185 for more on Image Mode.)

Changing your "Mode" is also a one-way move, and generally something you will only do for moving outside of an RGB process—like fine photography—and into other purposing of the photograph. This is where you might convert the file into CMYK for pre-press work, or into Indexed Color for making web graphics. You are, indeed, changing the working color space by necessity for a specific output. If you are going from RGB in your default working space (AdobeRGB 1998) to CMYK mode, you are going to move into your CMYK default space, as you have set it up in the Preferences. (Image>Mode>CMYK).

Most of the time, this is an action outside of any color adjustment in Photoshop, but there is one very cool move you can make here: editing in LAB.

LAB Mode

This little trick will either reinforce your understanding of color management, or send you back to the beginning to reread everything we covered about profiles, because it is a perfect

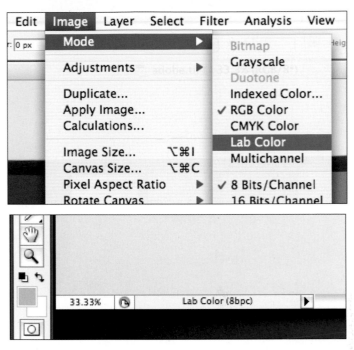

example of confusing terms and concepts. Here's what I mean.

Go to Image>Mode> and select LAB Color, as shown here. Once you select that, take a look at the information tab at the bottom of your image (make sure you've selected Show>Profile). You can see that we are now working and editing in the LAB "profile." This would suggest it is a working color space and, in fact, we have made it into one. Earlier, we defined it as a "connection" space—a description used to compare and contrast colors in three axes. Now we're using it to define all the rules of working with colors so we can edit them accurately in Photoshop.

This begs the question of why. Why would we want to change the mode—and thus the working color space—into this LAB space? Very simply, we change the mode to get a different "handle" on the adjustments we can make. To completely oversimplify LAB editing, let me

tell you this first. Once you convert the file from RGB to LAB mode, you have gone from R, G, and B channels to Lightness, A, and B channels—LAB. Lightness, for one, just deals with the luminance of the colors, not the colors themselves. Editing the file in LAB allows me to adjust only the luminance without messing with any color whatsoever. And that, my friends, is the very small tip of the iceberg into the depths of LAB editing, a discussion I will tease you with, but not try to detail here.

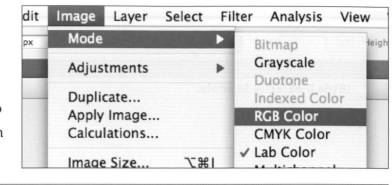

The biggest concern here is whether this conversion is destructive, and the general consensus is that, although it slightly alters the colors by going from RGB to LAB and back, it is a negligible conversion that is well worth the advantages of LAB editing. Here I'm showing two files, one is in AdobeRGB, and the other has gone from AdobeRGB to LAB and back to AdobeRGB.

When you go from LAB back to RGB, you will convert the file to whatever RGB space is set as the default in your Color Settings. If you want AdobeRGB, make sure you're set at AdobeRGB there. You will also get this screen, when you save the file, asking if you want to embed the profile, which you do.

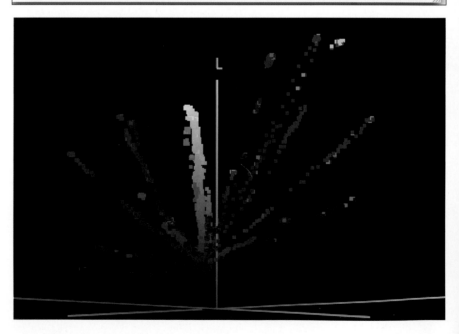

Here's how the colors look compared. To make it a little easier to compare, I've turned the AdobeRGB file to dark blue (rather than the "true color" option in ColorThink), and the converted file is set for "true color." You can see the differences, and you can see very minor colors popping out, which are the colors in the RGB>LAB>RGB converted file. Obviously, there are differences between the files, but they are minor.

I intend to go into a fairly basic explanation of some of the features of LAB editing as it pertains to color management, but as I've said, this is not the last word on what can be done with LAB color mode. Let's take a peek, and if you are intrigued, as my buddy Nick says, that is a rabbit hole you can go down on your own.

CMYK Editing

If you've read this far, read any of my other books, or been in any of my classes or seminars, then you know there are few things I'll flat out say are dumb. Let this be one of the few: CMYK editing is, in my opinion, senseless (unless, of course, you're doing pre-press production). I had a good friend come in to my studio not too long ago, fresh from a workshop and excited

about editing in CMYK. He felt it was a great way to get at some of the tones he was unable to reach in an RGB editing space and was currently converting files from RGB Color mode to CMYK Color mode and back again. Here, as simply as I can show, is why you shouldn't do edit in CMYK.

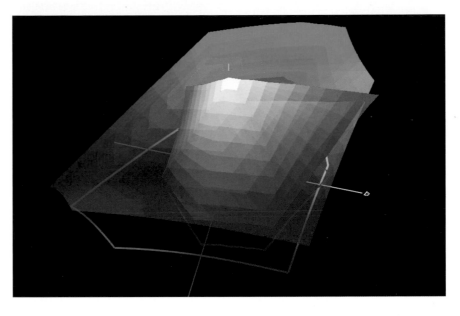

This is a gamut map of both the basic CMYK and AdobeRGB 1998 color spaces. The top, transparent space is AdobeRGB, and the space way, way inside AdobeRGB is CMYK. Do I have to say anything more? It's tiny. Converting to CMYK—any CMYK space—and back is doing huge damage to the file, regardless of how much you might like the "handles" of cyan, magenta, yellow, and black.

One of the arguments in favor of CMYK editing—in spite of this huge jump in gamut space—is that an ink jet printer has a gamut similar to a basic CMYK space, so since you're

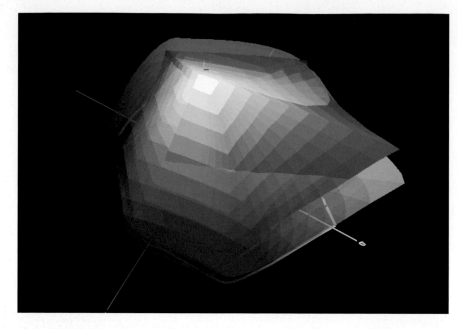

an RGB file into LAB mode by doing Image>Mode>Lab Color. That gives us the "handles," or channels, of Luminance, A, and B to perform precise edits. Then, we can switch it back to RGB for printing.

HINT: Switching from RGB to LAB doesn't change the file much, right? It really isn't as mysterious as it may seem. LAB is a "connection" color space, and the purpose of a "connection" space is to compare colors. It is defined by the necessity of being able to map to LAB and keep the specific characteristics of the gamut, and the gamut you're trying to connect to, so that you can compare two gamuts. How could that work if the connection space changed the gamuts you're trying to compare? It really is kind of a move "under the hood" of color management, allowing you to go to one of the basic tools the machine uses, and use it to make specific edits.

LAB editing is not restricted to Photoshop editing. RAW Processor, an independent software package, gives you the option of switching from RGB adjustments to LAB adjustments. If you like working with LAB handles, you can do it even at the RAW level.

going down to this small space, why not edit in it? In this comparison of CMYK and Premium Luster ink jet paper, they are similar. (CMYK is shown here in magenta.)

This argument seems sensible, but the fact is the colors are taking a huge and uncontrollable hit by going to this small gamut. Once you do this move, you cannot go back and recover your colors. It goes against every principle of "non-destructive editing." My advice is to learn to make those moves in LAB or RGB color modes. Your image quality will be the better for it.

I'll tear into LAB editing a bit, but first let me sum up. Even though a Mode change into a LAB space does not fit into what we've learned about working color spaces, and LAB does not show up as an available option as a space in our Color Settings menu, we can, carefully, change

GEEK ZONE: IMAGE MODE

"What exactly is Image Mode? This is the definition of "mode" that I found: A way or manner in which something occurs or is experienced, expressed, or done. That's perfect. The Image Mode is the way that Photoshop handles the pixel numbers.

We can have pixels with certain numbers, but we need a context to make sense of them.

Let's make an analogy to temperature. Let's say we have 40°F. When I'm listening to the weatherman, and it's May, 40°F is described as a chilly morning. If it is January in Boston, 40°F is positively balmy. You are handling the same numbers, but the first set is in Spring "mode," and the second set is in Winter "mode."

The confusing thing about Image Mode is it kind of overlaps with the color space idea. In the Mode menu, the main options are Grayscale, RGB color, CMYK, and LAB (among others).

The key to understanding Image Mode is knowing that the RGB and CMYK "modes" that you can select here will be using the RGB and CMYK color spaces you've set as defaults in your Color Settings (Edit>Color Settings). If you're going from LAB to RGB Image Mode, and your default RGB color space is AdobeRGB, then the image will go from LAB right to AdobeRGB color space.

Image Mode is not restricted to changing the color space, though—you have other editing choices. Image Mode is simply a way to organize our color numbers and to put them into context. It organizes them according to the bigger picture and the rules we've defined when making our Color Settings and Color Space choices.

| Edit | Image | Layer | Select | Filter | Analysis | View | Window |

Image menu:
- Mode ▶
 - Bitmap
 - Grayscale
 - Duotone
 - Indexed Color...
 - ✓ RGB Color
 - CMYK Color
 - Lab Color
 - Multichannel
 - ✓ 8 Bits/Channel
 - 16 Bits/Channel
 - 32 Bits/Channel
 - Color Table...
- Adjustments ▶
- Duplicate...
- Apply Image...
- Calculations...
- Image Size... ⌥⌘I
- Canvas Size... ⌥⌘C
- Pixel Aspect Ratio ▶
- Rotate Canvas ▶
- Crop
- Trim...
- Reveal All
- Variables ▶

Working in LAB Mode

Just about the furthest thing from my mind right now is to show you all about how to work in LAB color. First, if you really want the last, and best word on that, go to Dan Margulis' books, and probably the best one is *Photoshop*

LAB Color, The Canyon Conundrum, and Other Adventures. Dan is a guru of LAB, and in spite of sparking a rather spirited debate sometimes resembling fanaticism from both sides, he has come out of the last few years with his premise largely intact. Second, although I have a pretty tight grasp on how it affects image color, I am not an authority on LAB editing—I'm into

Smart Objects, myself—but you probably already knew that.

My intent is to open the door to a new realm of color control. By understanding the basics of color connections, you have a foundation for understanding what happens when you edit in a space like LAB. Maybe you'll like it, maybe not, but a little playing around in it will reinforce what we're talking about in this book.

(A) I'm going to dive right in with an example. Follow along, and then try to recreate these steps with an image of your own. I open my image in Photoshop through Adobe Camera RAW, working in AdobeRGB (1998). Here it is, and here is the standard RGB Curves dialog we know and love.

Here's the thing to understand: If I adjust anything here in RGB Curves, I'm adjusting not only the contrast and luminance—I'm also changing the color. It is very, very difficult to do anything here that does not shift the colors in some way. The manifestation of this that most people see is a strange color shift in the shadows or highlights when you try to make an image darker or lighter using the RGB Curves. This is the big difference, and the main benefit,

to using LAB—I can adjust the lightness (or luminance) without touching the image colors.

(B) I switch the image mode to LAB (Image>Mode>LAB Color).

(C) Now, when I go into my Curves adjustment layer I see three different channels—one is Lightness, one is "a" and one is "b." Channel "a" handles the magenta-to-cyan color range, and channel "b" handles the yellow-to-blue color range. The "Lightness" channel does only one thing—it handles the lightness, or luminance. The point is, you can go into that channel and make the image darker or lighter without affecting your colors.

(D) Here I'm just trying to show you some sample moves. I'm increasing the L channel contrast by making a steeper curve. This gives me a nice overall contrast boost without doing strange things to the colors.

(E) Next, I'm going into channel "b" and increasing the steepness of this curve, too. Here's where things get tricky and very powerful at the same time. Remember that "b" is the yellow-to-blue channel, right? So the move I'm making here (making the curve steeper) decreases the yellow and increases the blue in the shadow areas, and does the reverse in the highlights (increases yellow, decreases blue), much the same as what happens with an adjustment in the single blue channel in RGB.

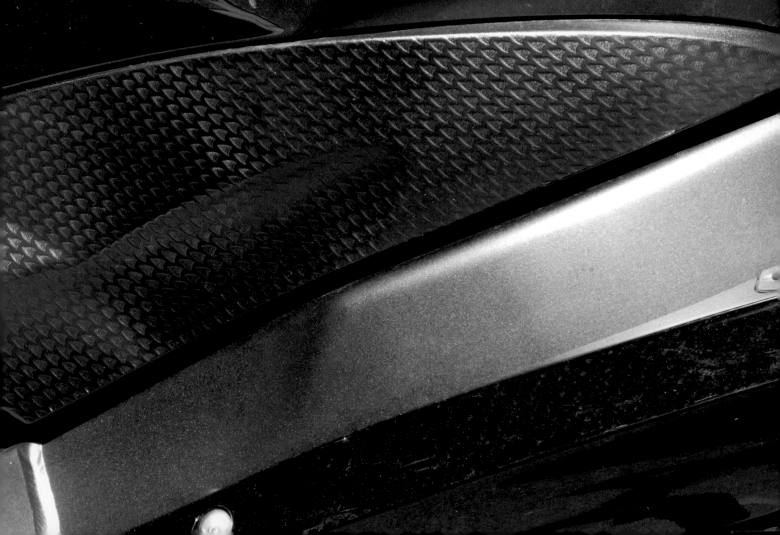

Now go into the "a" channel, keeping in mind that you are working on magenta and cyan. Between those two channels you have control over every color in your image.

The biggest warning you get about working in LAB is that it is really a "connection" space, so it is really huge. You can easily move colors out of the gamut of AdobeRGB 1998, your display, your printer, and everything else in your system if you're not careful.

(F) (G) Here I've made a few tentative moves in LAB, which have increased the vibrancy of my colors, and the range from shadows to highlights. The first shot is what I started with. The second is the result.

(H) Now, just for laughs, I'm going to use my "Gamut Warning" trick. View>Proof Setup>Custom and set the proofing to AdobeRGB 1998. Then, as we did on page 171, go to View>Gamut Warning, and take a look.

Without even trying too hard, I have pushed some colors outside of AdobeRGB; this does not even mention where they've gone relative to my printer and paper, which is probably a much further jump out of gamut. Dangerous, indeed.

I liken LAB editing to a nail gun. Bear with me; this is a really good analogy.

A nail gun allows you to work really fast. Roofers not only love them, but if you're trying to stay in business as a roofer, you have to have one. LAB color, because it allows you to darken and lighten without shifting color, and make color adjustments using two powerful channels, allows you to work fast, too.

A nail gun is, however, a really dangerous tool. You need to know where you're shooting nails, and what they are going into. Shoot a nail into rotten wood and it will come out the other side like a bullet. LAB color editing can shoot way past your mark, even into colors you can't see with your eyes, much less the colors you can see on your display.

Back to the example at hand—to deal with what the gamut warning has just told me, I simply go back and convert the file to

AdobeRGB 1998 again. Here is that dialog, Image>Mode>RGB Color. Remember, it will convert to the RGB space you've set up as default in your Color Settings (Edit>Color Settings).

There are a couple of things I want to make you aware of. First, you should be working in 16-bit files (which, if you're observant, you may have noticed from this example that I'm not). Also, remember that you are definitely changing the file by going back and forth to the LAB space, so you need to be as precise as possible about using it, keep the conversion to only one time, and avoid too much change.

Another interesting advantage of working this way is in the masking and selections you can make in LAB. The very briefest of examples I can offer here is in sharpening. If I select only the L channel, and apply Unsharp Mask, I'm working on a very important and influential part of the image information for determining edges—the dark-to-light range. By adjusting the sharpness of just the image file's luminance, I can avoid any unpleasant side effects of Unsharp Masking, like weird color haloing. (This is a bottomless rabbit hole of very interesting and very specialized techniques, and one that you may understand a little better by understanding the context of the colors and their little journey through the system.)

LAB Editing in Raw Developer

Just for laughs, let's look back at Raw Developer, by Iridient Digital. Here we have access to the LAB controls. Since we are working with a RAW file in the RAW processor, the conversion to and from LAB mode is not as destructive and therefore not as much of an issue.

We start with our RAW file, connect to the processor with the camera profile, push it around with LAB "handles," and process it out to our working color space. Because we are still processing the file in RAW, the conversion issue goes away. We can still make swings in LAB controls that are out of our range, but they get processed right to AdobeRGB (or whatever working color space you have selected). LAB editing in Raw Developer is just as powerful and a little less erosive.

Grayscale Conversion in the Color Journey

Black and White Are Colors, Too!

At one point in my career, my studio was in a building next to an electrician's office. The guys were great; they had no idea what I was all about, except that they figured I was a photographer, so I must have models floating in and out of the studio all the time—how could that be a bad thing? After they realized that most of what floated in and out of my studio were weird looking electronic widget products and overweight CEOs, most of them lost interest except for a couple of the guys—one of whom was

James, who had some curiosity about taking pictures.

James came in one day and started chatting to me about a show he had seen on TV. He said it was about this old guy—"Ansel" or something—who took pictures of mountains in black and white. (Keep in mind that A. Adams is my main man.)

"Mountains, in black and white!" James said. "Jeesh, what a scam!"

I was curious. "Scam?" I said.

"Yeah—seriously—mountains in black and white? How hard could THAT be?"

Indeed, James, this is a good question.

Black-and-White Photography

Let's start from the beginning and look at what we are actually doing when we take a black-and-white photograph.

Grayscale Conversion

First, and essentially, we are making a grayscale image from color. That is, we are converting that color to a shade of another color—gray. Back in the days of film, we didn't have much control over the value—or brightness—of that

shade of gray because the film had its own way of interpreting and translating colors. We had some controls, though, and they were based on filtering the light coming through the lens. If you take a color and restrict it, then that will translate as darker, right? If you take a blue sky, and put a red filter over the lens, and "read" its value (with a black-and-white film, in this case), the red filter restricts the blue color. The effect is to make the color read darker.

Grayscale conversion in Photoshop uses the same idea, except instead of filtering the lens (which you can still do, but most people don't), you are selecting what part of the three main channels you want to use to make the color gray. If you use primarily the red channel, blue areas will read as darker. Same idea.

Channel Mixer

As usual, in digital photography, there are about sixteen different ways to convert an image into grayscale, and for each way there is a cult-like following to claim their way is best. I start with Channel Mixer in Photoshop, because it best illustrates what we are doing and how this all links back to our color journey.

First, let's look at our little burple again. There's the little guy.

Now, I'm going to open up the Channels pallet. This pallet shows me each separate channel or RGB in the image, and in the case of burple, we can see that each channel is very different. The top channel is our RGB master, with all three combined. The Red channel is a mid-gray, Green is almost black, and Blue is almost white.

Just for illustration, I'm going to select the Green channel. Our little burple goes almost pure black with that channel selected. I've taken the available color channels, that read as very different values of luminance, and decided to render my grayscale—or determine my gray color—based only on the Green channel.

Channel Mixer lets you do that, but to certain degrees. In the Channel Mixer adjustment layer I select the "Monochrome" box. I zero out the Red and Blue channels, and hit 100% on the Green. Bingo—same value of gray.

The cool part is that I can go in and balance this to render my little burple color in any value I want. If I want white, I can use 100% Blue, and zero the others. If I want gray, then I take the Red channel to 100% and zero others. By using a selective mix of my basic color channels, I can control exactly what value I want to give my color.

Let's look at a few other colors. I'm going to show you a shot of the ColorChecker here, and a few different Channel Mixer settings.

This first shot is just the target in color, so you can compare the color renderings.

to gray equally. When you switch your "Mode" to "Grayscale" (Image>Mode>Grayscale), this is essentially, if not exactly, what Photoshop does to the file. (Photoshop does apply some adjustments to make the conversion more like what your eye sees.)

Next, I'm showing what it looks like if I use just my Red channel at 100%, and everything else at zero. Look at the red patch, the third from the left and second from the bottom. It has rendered as a very light gray. Now look at the blue patch on the left side, third down from the top—it is almost pure black (and actually looks blacker than the black patch on the bottom, far right).

Just to bring the point home, the next screen shows you some presets in Channel Mixer that are used to simulate film shooting with the filtering I mentioned above. Here is the "Black & White with Yellow Filter (RGB)" setting, and you can see that to simulate that effect, we need 34% of the Red channel, 66% of the Green, and 0% of the Blue. (The only real hard and fast rule I suggest when using Channel Mixer to convert to grayscale is to make sure the three channels add up to about 100%.)

The next shot shows I've selected "Monochrome" in the Channel Mixer dialog and set all three channels to 33%—I'm using all three channels equally. This is what is called a "Linear Desaturation," and this ramps the colors down

So far in our little burple's color journey, we have grabbed the three channels of color with our sensor, put them through our RAW processor, and taken the three separate, single channels of R, G, and B pixels and made one pixel with three channels of R, G, and B. Then, in Photoshop, we asked Channel Mixer to select precisely what percentage of each channel we want to use to create a single channel of gray. (Note that in the Channel Mixer window, our "Output Channel" selection is gray.)

This is a little confusing, because if you look at the channels pallet you still see three channels; the difference is the top channel is no longer in color—it is in gray. If you measure the image with "Info," you will still get three values for each channel of R, G, and B, but they will all read as equal and all three will have the same number on the luminance scale (0-255). Wc are still working in our AdobeRGB space and with three channels, but all three channels have been rendered to a gray value according to the mix we've asked for.

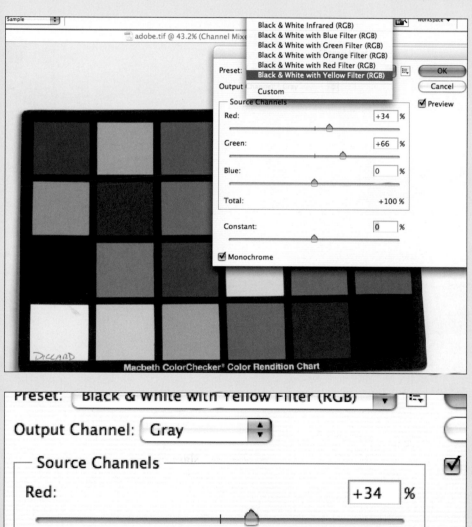

Maybe this will help. Here is the color of the red patch, shown on the Color Picker, before I apply Channel Mixer. The RGB values (seen at the bottom of the left column) are 177, 61, and 67.

When I apply the "Orange Filter" preset, it takes percentages of those numbers, and does the math to make them all equal. Here's what that looks like.

We've rendered the red color to gray, averaging it out to RGB channel values of 104, 104, and 104.

We are still working with our dear little burple, and we are still working in the AdobeRGB color space. We have remapped it—based on its original values—to have all three channels read as equal, and forced it to read a value of gray on a scale of white to black.

Black-and-White Conversion Example

This comes into focus when you see how it actually works in a photograph. Here's a shot of Barbara, processed with default settings in Photoshop. (Barbara will never trust me again when I tell her I'm "just testing a camera.")

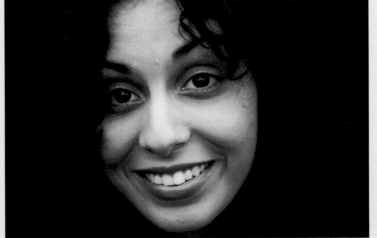

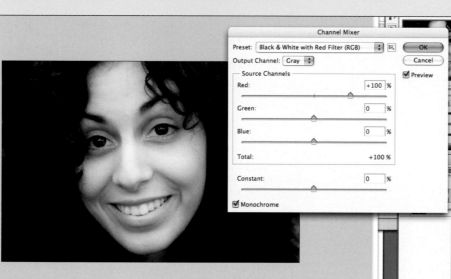

Generally, for fashion or portrait shoots, I would put a red filter on the lens. Here is what that looks like, done digitally with Channel Mixer. I find that much more flattering, for my purposes.

Again, what we are doing here is taking our basic RGB channels and deciding what color is going to go dark and what color is going to go light. In the second example, I've mapped the red values to go very light, and for this image it accomplishes what I want to accomplish.

Grayscale Conversion in RAW

This is all fine—the Channel Mixer grayscale conversion option—but as you may have guessed by now I'm all about the RAW processing. Adobe calls it a "non-destructive editing" workflow, as opposed to conventional adjustment editing, which is destructive. (Destructive editing in this means you start with a set amount of data, or information, and all you can do is push it around or toss parts of it out. You cannot add any information to the file with the general adjustments in Photoshop.) I like to take that concept to another level. Editing in

Here is Barbara with Channel Mixer using the G and B channels equally, and none of the R channel. I don't particularly like to render skin tones like this, especially on a young woman. It might work on a crusty old man—the kind of portraits that people describe as having "character"—but these channels darken lighter skin tones and accentuate any marks, freckles, and blemishes.

RAW is actually "constructive" or additive editing, not just "not destructive."

Thankfully, one of the improvements in CS3 was the addition of a Channel Mixer-type grayscale conversion right in Camera RAW. Here's what it looks like. (Click the HSL/Grayscale tab to find it.)

The way I use this is to first look at the three main channels, R, G, and B, and set those where I need them. Then I use the intermediate channels—or more correctly, controls—and smooth the settings to give it a nice transition from one main channel to the other. The settings shown are the standard Photoshop setting, and are a basic film-type response.

Grayscale Conversion in Adobe LightRoom

Adobe's LightRoom uses the same processor as Photoshop and Adobe Camera RAW, but has some very nice tools for controlling it. Here is a shot of LightRoom's HSL/Grayscale tab—check out the tiny button in the upper left corner.

Click that little icon, place your curser on any part of the image, and drag it up or down to make it darker or lighter.

In this next screenshot I'm showing the color target where I've clicked the red patch and dragged it up—mapping the red tones brighter and subsequently dragging the green tones

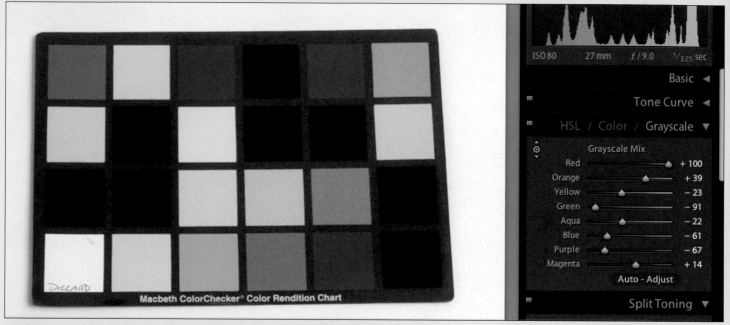

down. Compare the settings for that one with the default settings I showed you above. This is one of the many reasons LightRoom is getting such a great reception from photographers who need to work fast, but need to work well.

LightRoom also has some handy presets, on the far left of the "Develop" screen. Here I've selected the "General Grayscale" setting.

It also has User Settings, where you can start with one of their presets, change them, and save them as your own, or you can just start from scratch.

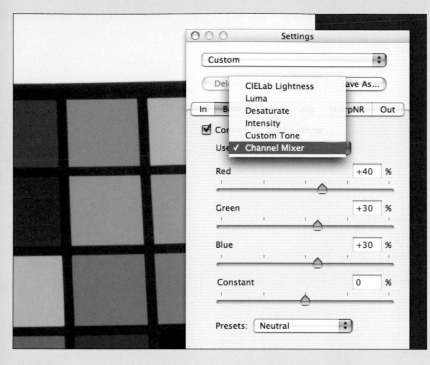

At this point I really don't know how things are going to go with LightRoom. Adobe typically "cherry-picks" nice features from other software and then builds the cool stuff into Photoshop. My guess is that you're going to see some of these features built into new versions of Camera RAW and have them available in Photoshop.

Grayscale Conversion in Iridient's Raw Developer

I am throwing this out there to support Iridient Digital's hard work, and taunt Adobe with a powerful and professional set of features in RAW processing. Raw Developer has a nice array of options for grayscale conversion in RAW. Here is a shot of the controls.

Under the Black-and-White tab is a great selection of options for converting the RAW RGB information into grayscale values, including using the "Lightness" channel from LAB. I still think the Channel Mixer option is by far the most powerful and gives me the most control, but it's nice to work with a package that gives me more to choose from.

You also get a pleasing little array of presets— some mimicking film renderings—as well as the ability to save your own settings like most other packages.

There are a couple of other RAW processing packages out there—one in particular—that has film "profiles" which again mimic not only the color response of a black-and-white film, but also the grain. I'd show you this, but it would turn into a listing of independent RAW processors and a feature shootout pretty quickly.

Suffice to say, they are all doing the same thing, but with a few different knobs and switches. They are all taking that basic information from the sensor, in red, green, and blue, and figuring out how bright to map that color. The file is then built into the working color space you select and sits on the same three dimensions that any of our RGB colors sit on.

Step One: Prepare the tools.

Brush Settings: Mode—Normal; Opacity—50%; Flow—50%

Foreground/Background color: White/Black (default)

Layers Palette: Visible (Window>Layers)

Step Two: Create the layer and mask.

Click the half black/half white circular icon at the bottom of the layer palette—"Create new fill or adjustment layer." Select the adjustment you wish to make—such as making the image darker with Levels—and make the adjustment.

Select the layer Mask—the white rectangle next to the Adjustment icon. Turn the mask black by using the "Invert" command (keyboard shortcut Command–I).

Step Three: Make the mask selection directly on the image.

With the (now black) mask selected, use the Brush tool to "paint" white on the mask. The painted areas of your image will become visible, or active. The active areas of your adjustment show up as white on the black layer mask.

Tips and Tricks

▶ *The "{" and "}" keys make your Brush tool a smaller and larger diameter, respectively.*

▶ *"X" switches the foreground/background colors.*

▶ *"Painting" black over a white area of the mask "covers" the edit, allowing you to change and refine your selection.*

▶ *The "Opacity" slider on the Layers palette (different from the opacity setting for the Brush tool) allows you to adjust the how the strongly the layer edited appears.*

PART 6:
SHORTCUTS, DETOURS, AND THE SCENIC ROUTE: THE COLOR MANAGED WORKFLOW

W e've seen the pieces of the puzzle, and how they fit together in a few examples to make a workflow. Let's take a look at the whole thing, but with some "Alternate Path Options" for sidetrips, enhanced controls, and as my friend Nick Wheeler says, "rabbit holes" to explore. Follow along, give it a try with your own images, and find your own color "pipeline."

The Scenic Route:
A Basic Color Workflow

This sequence is a basic method of working to show you what the colors are doing, and what you can do with them. We will start with a simple image that has fairly simple color management needs.

Capturing Color: The Histogram

My example image is at the top of the next page. The contrast range is not too extreme and I want to place this as high on my exposure curve as I can without clipping my highlights.

and the data increases exponentially through the midtones and highlights. I have some room at the right on the histogram, and I can see the shadows are bunching up on my camera's display, so I'm going to adjust my Exposure Compensation half a stop. This is what my final in-camera histogram will look like.

I've allowed the tonal information to fall higher on the histogram, giving me more data in the image file. This is a very subtle difference, but remember that you cannot process something that is not there. Making this move allows you to get more out of the file later.

Capturing Color: White Balance

I want to be keenly aware of the white balance setting in the camera. This ultimately is something I can and probably will change in RAW file processing, but this does a couple of things for me. For one, it tags the file with a white balance setting that most RAW software can see—this saves us a few steps and gets us closer to the final image. Also, the white balance setting makes subtle changes in how the histogram is displayed on the camera, thus affecting our decisions in adjusting exposure.

For the above image, I've set it between the Daylight (5500K) and the Tungsten setting

Above is the resulting histogram when the image is shot using automatic Shutter Priority settings. This is fine, but there is some room to expand the information. Remember controlling exposure with EV (page 94)? We can see there is very little information in the shadow areas

(3700K)—something I can do on my particular camera. The main light source in the image is from a halogen spot, with daylight coming from a window, so I have the extremes of the warm Tungsten and the cool Daylight. I've decided to keep them both and walk the middle.

Connecting Color: RAW File Process

I take the photograph. Once I bring the file into Adobe Camera RAW, I click the "Workflow Options" and see the dialog where I choose my working color space.

Alternate Path Option:
RAW Developers, page 220

I always choose AdobeRGB (1998) as my working color space—it is a standard practice. Remember the path: I start with red, green, and blue "mosaiced" pixels, and use Adobe Camera RAW to "de-mosaic" the file and build pixels that are RGB pixels. This means that I start with colors that connect using CIE XYZ and I direct Camera RAW to connect the colors to AdobeRGB.

Camera RAW must display the colors correctly, so our system simultaneously connects the colors to the display profile of our calibrated monitor when it connects the CIE XYZ profile to the AdobeRGB profile. Then, when we make color corrections in Photoshop, we see the same thing we saw in Camera RAW.

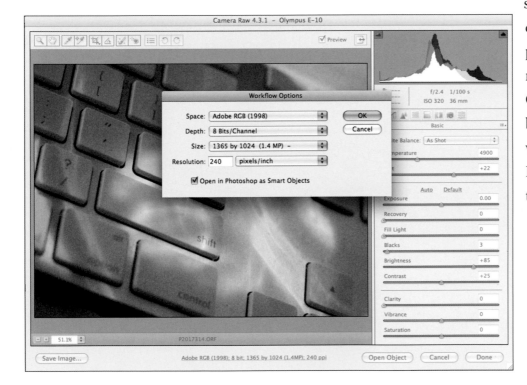

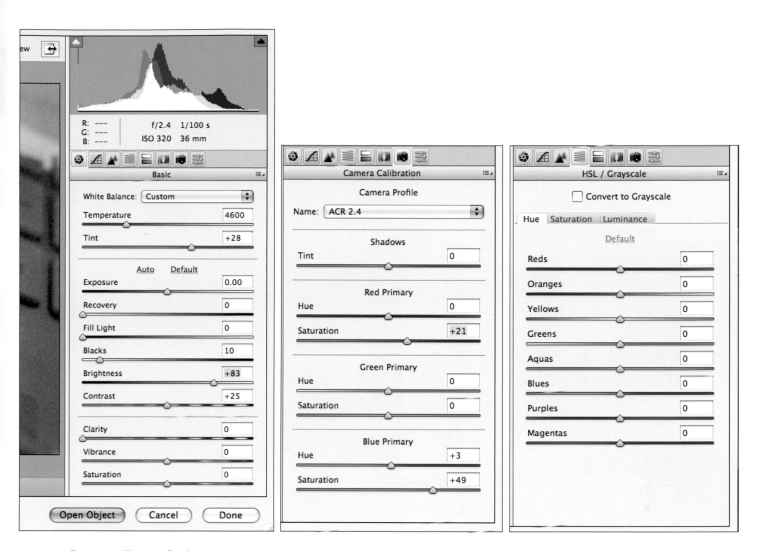

Controlling Color:
RAW File Adjustment

Now I get to move the colors around.
I've captured and connected what I need—now
I can edit the image data to get the photograph
I visualized.

I start with the most basic color setting—White
Balance—and adjust it until I get what I like.
Then I adjust the sliders for Exposure, Blacks,
Brightness, Contrast, etc. I may even go into the
Camera Calibration tab and adjust the hue and

saturation of the processing. I may go further
and choose the HSL/Grayscale tab, and use that
to finely tune each main color channel, as well
as intermediate color channels.

Remember my gamut map. I'm physically
moving colors from one place on that map to
another, and changing relationships of colors
too.

Here is a gamut map of our first Camera RAW default file and one of our adjusted file. We've pulled things out a bit, spreading the colors into the blue and magenta areas of our XYZ plot.

Constructing Color: Additive Editing and Smart Objects

Remember that we are building this file from the RAW data—not stretching pixels that are already built. This makes it is a constructive workflow ("non-destructive," per Adobe). That's why we love it.

Now I select "Open Object" at the bottom of my Camera RAW control panel. This brings my RAW file into Photoshop as a Smart Object. The RAW Smart Object simply allows you to access the Camera RAW adjustments later and very easily work in the constructive workflow we love. Here is that layer, showing the Smart Object icon.

There is a crucial connection between what Photoshop works with and our display profile that ensures we are seeing the colors accurately. This takes the colors in the AdobeRGB (1998) color space and uses the CIE XYZ map to connect them to the display profile. In some cases, colors in the file will exist in the AdobeRGB space and need to be remapped to fit into the display space,

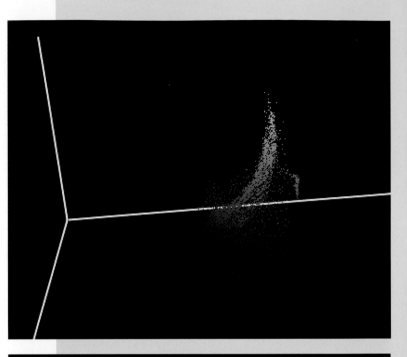

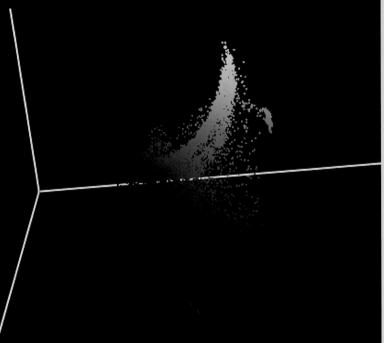

using whatever rendering intent we have chosen.

At some point in my workflow I may need or want to change the Smart Object into a normal layer, and I do that by Layers>Smart Objects>Rasterize. This renders the RAW file into a typical layer and eliminates our access to the RAW processing information. This does not really change our colors—just our controls.

We now have our standard adjustment layers and color corrections available. Out of all those options, I only like to use Levels and Curves because they are the most basic controls. Curves in CS3 gives you a superimposed histogram, allowing you to make Curve adjustments and see what that is doing to the histogram. This is a great way to learn what you are doing to the image with Curve adjustments, provided you know what the histogram is all about.

One of the most powerful controls available here is editing in LAB mode. We can go into Image>Mode and select LAB color, giving us L, A, and B "handles" on our colors, while making little to no change on the file. If you are using Smart Objects, you will get this warning dialog—you can click "Don't Rasterize" and you'll be fine.

Once you are in LAB mode, open a Curves adjustment. Notice that you don't have your familiar R, G, and B curves—you now have Lightness, A, and B for controls. The big deal here is the Lightness channel. This allows you to specifically adjust just the luminance of the image without changing the color. We have talked about using LAB to "connect" colors, as an alternative to the CIE XYZ connection space, but here we are using LAB as a working color space. There will be a change—a slight change but a change nevertheless—in the colors when we convert from one space to the other.

Finalizing Color:
Connecting to the Printer

Alternate Path Option:
Gamut Warning, page 227

Sending the file to the printer from Photoshop is the most dramatic and destructive step and should be done carefully and precisely. It is severe because we are going from one way of producing color—with light—to a completely different way of making color—with ink. As we've seen, the color gamut available on even the best printers is limited, so we're remapping many colors into a much smaller space.

The place to do that is in Photoshop, rather than the printer software. When we hit "Print," we get this dialog.

Select "Photoshop Manages Colors," and the

printer profile that matches our paper/printer combination. I've chosen SPR2400 Premium Luster Best Photo. Photoshop connects the RGB colors in AdobeRGB (1998) to the RGB profile of the printer, using LAB as the connection space (LAB is better than XYZ for this job). The printer driver then translates that RGB profile into a CMYK profile to know how much ink to spray.

I cannot stress the importance of using precisely the right profile here. This is no place for creativity and exploration. Use the best profile available for the printer and ink— invariably that is the one built for it, either by you or the manufacturer.

Alternate Path Option:
Custom Profiles, page 224

Since we have already controlled the color, we're going to turn off all color controls in the printer driver. How you do that varies from printer to printer, but it must be done or your image quality will certainly suffer.

Finally, we examine and evaluate the print in the lighting it will be viewed under. Congratulations—you have finished a complete, color-managed workflow.

Alternate Path Option:
RAW Developers

One of the great things happening right now is the blossoming array of RAW developers available to digital photographers. There are some sweet little packages that are free, there are the venerable old standbys like Bibble, and there are some new and interesting entries including Apple's Aperture. The decision to use a developer is based as much on taste as it is on logic. The interface—the controls available to the user—are kind of like driving a car; you either find the driver's seat comfortable and well-positioned, or you could suggest some improvements, or maybe you hate it. Most software has adjustments to make the fit closer to custom, but there are some things that are built in.

The other aspect of the processor, like cars, is performance. Some RAW processors do a

better job than others—in some cases that is a general conclusion, but with others it depends on the camera and file you're working with.

Assume I want to use something other than Adobe Camera RAW. I have been really intrigued by Iridient Digital's Raw Developer, so I'm going to show you that here. (See the Geek-Zone on page 122 for more on Raw Developer.)

Raw Developer controls are laid out much like the path of color through the system, and this organization gives us some nice handles to get a precise grip on the way the developer processes the files. Here is the first tab, labeled "In."

Near the top of the window you have an exposure slider that you can switch from "Use Camera RGB" to "Use Luminance." You'll also see the Color Matrix and Tone Curve settings, which allow you to specifically define how the RAW Red, Green, and Blue data is mapped.

At the bottom of the pane are the Input/Working profile menus, and it is here that you can use a camera profile that you've built with a profiling program like i1 Match. You can also determine the working space profile, which is what the software assumes is where you want to work with the color. In these screenshots, I'm getting the processing software into the same color place as Photoshop, using AdobeRGB (1998) as a working space, and using the display profile to connect with that space in order to

make sure the colors look right. Keep in mind that we are not setting the working space of the file coming out of the processor; we're just setting what the processor is going to use while it's there.

The next tab over is "B&W," and there we have some nice options as well. Selecting the pull-down menu to access a whole bunch of interesting ways to generate a black and white image—

among them is my old standby, Channel Mixer.

Next you have the "Curves" tab, and this is where you'll find LAB controls (if you're a die-hard LAB editing fan) as well as RGB controls.

Under the "SharpNR" tab, Raw Developer provides some pretty intense controls that will make you happy if you're of the opinion—as many are—that Photoshop is lacking in the sharpening and noise reduction areas.

| In | B&W | Curves | Adj | SharpNR | Out |

Color Matching Quality:

Best ▲▼

Color Matching Rendering Intent:

Perceptual ▲▼

Output Profile:

Adobe RGB (1998) ▲▼

☐ Use Custom Orientation 🔲

Rotation: Use Image Value ▲▼

Minor Adjustment 0.00

△

☐ Flip Horizontal
☐ Flip Vertical

☐ Crop 🔲

Constrain to: Unconstrained ▲▼

(Clear) Size: 2240 x 1680

(Send to Batch) (Process And Save As...)

Finally, the "Out" tab supplies the output profile, some cropping, and scaling options. Here I am making sure my Output Profile is set to AdobeRGB (1998). It is a clean layout, and the steps are set up in order from left to right— In to Out. It's a slightly different set of handles than what we see in Adobe Camera RAW, and for some people a better fit.

The color steps are pretty much the same, with the exception of the ability to use a different camera input profile. Adobe Camera RAW has it's own "profile," and within that you don't get to chose which profile you use, even if there were more than one. Raw Developer allows the user to go in and build custom input profiles, or use alternates as a starting point for your control.

Here is the breakdown of the steps with Raw Developer: the RAW file connects with the "profile" using CIE XYZ. This connects to AdobeRGB—again, using CIE XYZ—and AdobeRGB connects with the display, all within the Raw Developer software. You make your adjustments, and the software again connects the profiled RAW file (still CIE XYZ) to AdobeRGB to make your TIFF, JPEG, etc. for Photoshop, as an AdobeRGB (1998) file.

Then we go back to Photoshop and into the core process right at the point that we start making adjustment layers. (Using Smart Objects is not an option with this workflow, since we are adjusting the RAW files outside of Adobe.)

There is way more here than I ever use, much less on a regular basis. I am of the opinion that sharpening should only be done slightly on a RAW image if at all, and then an Unsharp Mask layer added in Photoshop after you size the image for the final output. "Final" sharpening in RAW almost never seems to hit the target, but that is why there are different packages.

Alternate Path Option:
Custom Profiles

Since we covered how to build your own profiles on page 103, let's just touch on how and where to get custom or manufacturer profiles, and what to do with them.

Photoshop will start up and scan all the appropriate folders for the appropriate profiles. First, you have to figure out where they go (or where Photoshop goes to look for them), and then it is a simple matter of putting them there.

In Apple platforms, they go in the main Library folder, under ColorSync. Go to the hard drive, Library>ColorSync>Profiles. In Windows,

search for .icm file extension (ICM profiles are just the PC version of ICC profiles), and put them there. I'm not trying to be difficult—they just keep moving them around and burying them deep in the system.

So, let's say you want to run Crane Museo Silver Rag (one of the yummiest papers out there, by the way). Start by going to the Crane Museo website (http://www.museofineart.com/). From there, look for "Downloads" or "Support," or "Profiles" which, in this case, is right on the main page and easy to find.

You'll note that this takes you to a page titled "Printer Settings and Profiles." It is crucial to use the correct printer setting with the profile you chose. The profile, as we've seen building our own, depends very much on the selected printer paper and quality setting, and if you use the wrong combination you're likely wasting time.

I choose Museo Silver Rag, and it brings me to this page. (Note here, please, a nice big list of printers, and a .pdf file curiously labeled "Instructions" for each printer profile. Hmmm. Makes you think you maybe should read that, huh?)

MUSEO SILVER RAG		
Printer	**Profile**	**Instructions**
Epson Stylus Photo R800	ICC Profile	🗎
Epson Stylus Photo R1800	ICC Profile	🗎
Epson Stylus Photo 2200	ICC Profile	🗎
Epson Stylus Photo R2400	ICC Profile	🗎
Epson Stylus Pro 3800	ICC Profile	🗎
Epson Stylus Pro 4000	ICC Profile	🗎
Epson Stylus Pro 4800	ICC Profile	🗎
Epson Stylus Pro 4880	ICC Profile	🗎
Epson Stylus Pro 7600 / Epson Stylus Pro 9600	ICC Profile	🗎
Epson Stylus Pro 7800 / Epson Stylus Pro 9800	ICC Profile	🗎
Epson Stylus Pro 7880	ICC Profile	🗎
Epson Stylus Pro 9880	ICC Profile	🗎
Canon IPF 5000	ICC Profile	🗎
HP Photosmart Pro B9180	ICC Profile	

Please read these instructions. In those instructions you will find the paper settings to use, and you may even find the answers to questions like, "Where does this go?" You'll also notice one other thing—most of what you see listed here are Epson printers. There is one lonely Canon and one HP, but this goes back to my discussion of which printer to buy, and the support available. Stay in the mainstream and you'll have more tools to work with.

I download my file for the Epson R2400, and it goes to my desktop. I drag it into my Library>ColorSync>Profiles folder and I'm done.

Keep in mind that Photoshop will not see it until you restart Photoshop. Once you do that, you can print in your usual manner. Print>Let Photoshop Determine Colors and select the new profile.

Alternate Path Option:
Gamut Warning

We've gone through a couple of examples of using Gamut Warning, so here is a brief review.

We're ready to connect our colors to the printer, but here is where we stop and check our color for gamut problems.

First, we set the "Proof Setup" to the paper and printer we're using. Be sure to choose the exact paper profile on which you'll be printing. (View>Proof Setup>Custom, then select the paper/printer under "Device to Simulate.")

Hit OK, then go back to View, and select "Gamut Warning."

This displays an overlay indicating which colors in the image are within the working color space—Adobe RGB 1998, in this case—but are outside of this printer/ink combination. This screenshot shows a deep blue area that reproduced well on my paper/printer combination—the Epson R2400 with Premium Luster paper. That area is flagged with gray.

Depending on my workflow, I have several different ways to deal with this. The standard Photoshop adjustment I would use for this would be Hue/Saturation. I open that dialog and click the image area that is out of gamut. Then I move the color around a bit until it has moved into gamut in an acceptable way.

In this case, adjusting the Saturation slider down a bit and moving the Lightness up corrects the problem.

Smart Object Option: If I'm working with my Smart Object workflow, I re-open the RAW file by double-clicking the Smart Object icon on the layer. That just re-opens the Camera RAW dialog, and then I'll make the same Hue/Saturation moves—I go into the HSL/Grayscale tab, pick the right colors, and adjust the luminance and saturation. Live

preview is not an option here, so I must make the adjustment, hit OK, and see if it works. The difference is I'm making the adjustment to the RAW file, so it is a constructive adjustment, not a destructive one.

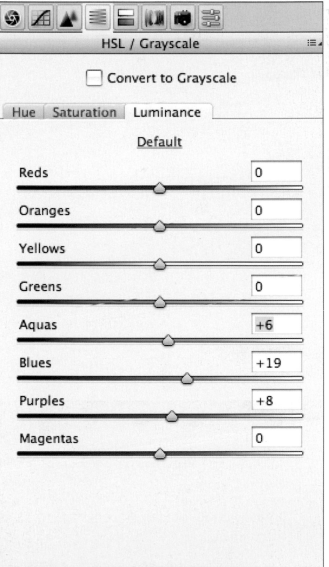

The result is I have complete control over how the colors move in order to fit into my printer capabilities, and not the color management system. Think back to the gamut map we saw showing rendering intents. We've done exactly the same thing, only this time, manually. We've picked the problem colors with the gamut warning feature, moved them into the happy place where our printer can deal with them, and we've done it exactly the way we want to.

Rescuing Burple: Advanced Color Editing

Every good story has a punch line, and this is no exception.

We have watched the journey of our little colors—burple, in particular—through the visualization, capture, viewing, processing, and

printing process, all to finally see the presence of our little guy in the final print. The truth is, our little burple was not always as he seemed.

I first saw our little burple on a walk down one of my favorite beaches. There he was, peeking behind some wind-blown grasses—a lone beach iris in a sea of moving green. Well, here is a confession: That was not the first time I've encountered that color. I've struggled with burple

for years now, each time trying to capture that vivid tone of blue and purple in an iris. The first time I photographed burple I was shocked that the color I got was a plain, primary blue, so right off I knew I needed to handle this image with care and forethought—with vision.

My digital capture was fairly routine—I made sure the white balance was set properly and the exposure was adequate to get the most color information. Here was the histogram, as I shot it. You'll note that the exposure is "pushed up" a bit—the shadows are as high as I can get them and there are

a few highlights that are off the chart, but those lost highlights I can live with; they are mostly direct sunlight reflecting off the grass.

I open my file as a Smart Object and this is what I see. Notice in particular that I've pulled the background of the file out a bit so it is a neutral

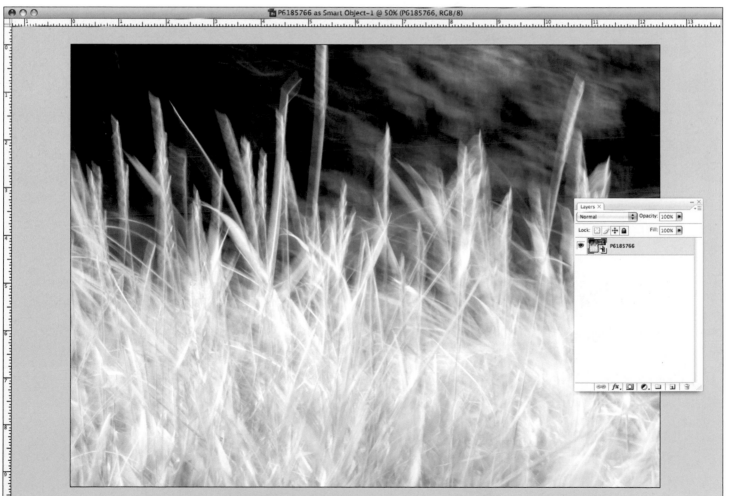

Using the "Color Picker," I click on our color burple to see what it really is and the ugly truth is revealed—the lovely burple is gray at best. In some spots, it is even a muddy brown.

How could this have happened? How could burple have been lost, and how did the little guy fool us?

Well, let's look at that last question first. The burple is sitting in a field—a context of green. It contains enough blue and magenta to play off the green and give us the impression of contrast and balance, so we actually see the color as more burple than it is. I know, however, that it is not the same vibrant color I saw on my walk, and if I make the print, that truth will be concrete—my print won't have the same vibrant intensity that I saw on the beach, or in my mind's eye. Through experience, and understanding how my eye is fooled, I can pay attention to the details that are fighting against me.

Here is what I know—the sensor and processing face a couple of challenges, one of which is balance. I want to hold all the greens and have a balance to the colors and tones that closely resemble what the eye sees. In the process, our little burple is sacrificed for the overall balance—I must go in and reclaim him.

gray. This allows me to view the colors with a clean context and no influence from neighboring colors outside of the image.

Right off the bat, it looks fine. Our greens and browns seem to be where they should be, and our burple is sitting there nice as you please. Now take a closer look.

The way I'm going to do that is to reprocess my RAW file—some call it "going back to the chip"—and pull out the colors I need. Luckily, I have my RAW file right there as a Smart Object. I double-click the Smart Object icon and I am right back to Camera RAW.

First, I make a second Smart Object layer, because I don't want to mess with my nice greens (Layer>Smart Objects>New Smart Object via Copy).

Next, I open my new Smart Object layer (double-click the icon) and I get my Camera RAW dialog. I've zoomed right in to my burple—I want to get as much of the green context out of it as possible so I can see it clearly. I've even shrunk the Camera RAW window to "crop" the green out as much as possible.

Now, I'm going to grab burple and massage him into place. I go into the HSL/Grayscale tab and boost my "Blues" and "Purples" saturation. I also go to my main adjustment tab and make some saturation and color balance moves to get the burple to be more "burple."

Here's the main tab (Basic), the adjustments I've made, and the preview. This looks right to me, maybe even a little overboard, but it will be great. I can always adjust the opacity of that Smart Object layer to "feather" my adjustment, but only if I do go a little overboard. I hit OK, and it applies the changes.

Of course, this has made an overall change to my image—a "global edit." I really only want it to affect my burple, so I make a mask. Click the "Add New Layer Mask" icon, "Invert" the mask to black, use the brush on the mask to allow the

edited Smart Object to filter through, and you have your burple. (See page 208 for more on layer masks.)

The result seems a little abrupt, so I go to the "Opacity" control and turn it down a bit—in this case to 78%.

The final result is just as I envisioned and exactly what I want to print. I've taken my little burple from the subject—the iris on the beach—and carefully pushed him into place. I can now make a print that is true to my vision. On that windy day, I saw the photograph, I captured the colors, and I took them on their journey towards becoming a final print.

black point

The *density*, and occasionally the color, of the darkest black reproducible by a device. For a printer, this is the density and neutral color balance of the darkest black achievable using the printing inks; for a monitor this is the density of the monitor when displaying black, and can be adjusted by setting the *black level*.

brightness

The perceived response to light intensity. This response (in a human observer) is *non-linear*.

CIE

Commission Internationale d'Éclairage (International Commission on Illumination). An international association of color scientists that has assembled many of the standards used as the basis for *colorimetry*.

CIE LAB

(Also known as LAB.) One of the two main color spaces proposed by the CIE to attempt a *perceptually uniform* color space. L is the lightness value, a is the red-green *opponency*, and b is the blue-yellow opponency. CIE LAB is one of the two color spaces used as a PCS in ICC-based color management.

CIE XYZ

Shorthand for the CIE XYZ *color space*. This defines colors in terms of three theoretical *primaries*, X, Y, and Z, that are based on the CIE research into human color response (the CIE *Standard Observer*). XYZ is not *perceptually uniform* and therefore can't be used for computing color distance. XYZ is one of the two color spaces used as a possible *PCS* in *ICC*-based color management.

CMM

Color Management Module. Some people know it as an abbreviation for Color Matching Method, or Color Manipulation Model. In any case, a CMM is a drop-in component that provides the "engine" for profile-to-profile conversions. It defines how colors are computed using the sample points in the *profiles* as guidelines.

CMS

Color Management System. Software dedicated to handling device-to-device conversion of colors. The ICC-based model for a CMS consists of four components: a *PCS*, *device profiles*, a *CMM*, and a set of *rendering intents*.

color space

An instance of a *color model* in which every color is represented by a specific point in space, and thus has a specific set of three or more numbers that describe it. An example would be the RGB space of a particular monitor, where a certain color has a specific set of three numbers representing the amounts of the red, green, and blue *phosphors* needed to produce that color. Note that there can be many color spaces that use the same color model (for example, every monitor essentially has its own specific color space, but all use the RGB color model).

color temperature

A description of the color of light in terms of the temperature of the light source, in *Kelvins*. Lower temperatures are redder, higher temperatures are white, and the highest temperatures are bluer. Technically we should only refer to the exact color temperature of a *blackbody radiator*. If the light source is not a true blackbody radiator, then it's more correct to speak of the *correlated color temperature* of the light source.

colorimetric intent

The two *rendering intents* that try to preserve *colorimetry* of color—colors are mapped to an exact match wherever possible, and where not possible (because the color is out of the target *gamut*), the color is mapped to its nearest equivalent. In most cases, this conversion should include a remapping of the *white point* so that this colorimetric

match is relative to the target white point—this is known as *relative colorimetric*. In some cases (in certain stages of proofing), the colorimetric match should be absolute—the colors should be converted as if the match were being done relative to the source device's white point—this is known as *absolute colorimetric*.

colorimetry

The science of predicting color matches based on ever-growing research into typical human color vision. Much colorimetry is based on the work of the *CIE*.

ColorSync

Apple's implementation of *ICC*-based color management. On Macintosh computers, the components in the Mac OS that handle such things as making *profiles* and *CMMs* available to programs that need to convert colors.

destination profile

In a color conversion, the *profile* that defines how to convert colors from the profile connection space (*PCS*) to the target *color space*.

dynamic range

A range from brightest white to darkest dark as measured in *density*. The dynamic range of measurement devices (such as scanners, cameras, or *densitometer*) describes the distance between the darkest black the device can measure before it is unable to detect differences in brightness, and the brightest white it can measure without overloading. Also applied to media (for example, prints or transparencies) and images, to describe the range from the darkest black to the brightest white.

editing space

A *color space* intended specifically for editing of color values. An RGB editing space should ideally (1) be *gray-balanced*; (2) be *perceptually uniform*; and (3) have a *gamut* large enough to contain the values being edited.

gamma

(1) The degree to which a device or *color space* is *non-linear* in tonal behavior, represented as the exponent of a power function.

(2) In *CRT* display systems, the relationship between input voltage and output *luminance*.

(3) In *color spaces*, the mapping of tonal values to perceived *brightness*. A gamma value of around 2.2 is generally considered *perceptually uniform*.

gamut

The range of colors and *density* values reproducible on some output device such as a printer or monitor. This is sometimes split into the *color gamut*—the range of colors limited by the *primaries* used—and the *dynamic range*—the range of *brightness* levels from the darkest black to the brightest white of the device.

ICC

International Color Consortium. A consortium of color-related companies that have cooperated to standardize *profile* formats and procedures so that programs and operating systems can work together.

ICM

Image Color Management. The implementation of the *ICC* profile specification in Microsoft Windows.

Input profile

A *profile* for an input device such as a camera or digital camera. Not to be confused with a *source profile*.

Kelvins

(K) The unit physicists use to describe temperature, with the scale starting at absolute zero—the temperature at which all atomic activity stops.

lightness

Relative *brightness*. The brightness of a surface or light source relative to some absolute white reference.

linear

A simple relationship between stimulus and response, whereby (for example) doubling the stimulus produces double the response. The human sensory system is predominantly *non-linear*.

luminance

The amount of light energy given of by a light source, independent of the response characteristics of the viewer. More precisely, luminance is the *luminous intensity* per unit area of the light-emitting surface.

non-linear

A complex relationship between stimulus and response, where (for example) increasing the stimulus produces less and less response. The human sensory system is pre-dominantly non-linear.

output profile

A *profile* for an output device such as a printer or proof-ing device. Not to be confused with a *destination profile*.

perceptual intent

The *rendering intent* that tries to preserve the perceptual relationships in an image, even if this means remap-ping all colors both in-*gamut* and out-of-gamut. This is usually, but not always, the preferred *rendering intent* for images that contain many out-of-gamut colors, but if all colors are in-gamut for the target *color space*, *relative colorimetric* may be preferred.

profile

A file that contains enough information to let a *CMS* convert colors into or out of a specific *color space*. This may be a device's color space—in which we would call it a *device profile*, with subcategories *input profile*, *output profile*, and *display profile* (for input, output, and display devices respectively); or an abstract color space such as a *working space* like Adobe RGB (1998).

profiling

The act of creating a *profile* by measuring the current state of the device. Sometimes also known as *characterization*.

rendering intent

The setting that tells the color management system how to handle the issue of converting color between color paces when going from a larger *gamut* to a smaller one. The *ICC* specifies four rendering intents: *perceptual*, *saturation*, and two types of *colorimetric intents*.

saturation

The property of the light from a surface or light source by which we perceive the purity of the light—how much does the light contain photons of only a certain *wavelength* (highly saturated) or a mixture of many wavelengths (less saturated).

source profile

In a color conversion, the *profile* that defines how to convert colors from the first *color space* to the profile connection space (*PCS*). See also *destination profile*.

space

(1) In color and color management, shorthand for a *color space*. We often refer to the "RGB space" of a monitor, or the "CMYK space" of a printer, when referring to the specific definitions of the colors reproducible on that device in terms of its *primaries*.
(2) The final frontier

spectrum

The full range of possible energy levels (*wavelengths*) of *photons*. The *visible spectrum* refers to the range of energy levels (wavelengths) visible to the eye.

white point

(1) The color (often described in terms of color *temperature*) and intensity (often measured as either *luminance* or *density*) of the brightest white reproducible by a device. For a printer, this is the color and brightness of the paper. For a monitor this is the color temperature and luminance of the monitor when displaying white, and can be modified.

(2) The color (usually described in terms of color temperature) of a light source.

working space

The *color space* chosen as the default space for documents of a certain mode. For example, in Adobe Photoshop an RGB working space is used as the default color space for new RGB documents, and a CMYK working space is used as the default for new CMYK documents. In most cases the best choice of working space is an *editing space*, but any bidirectional space can be used.

INDEX